Paul Stirton

RENAISSANCE PAINTING

PHAIDON

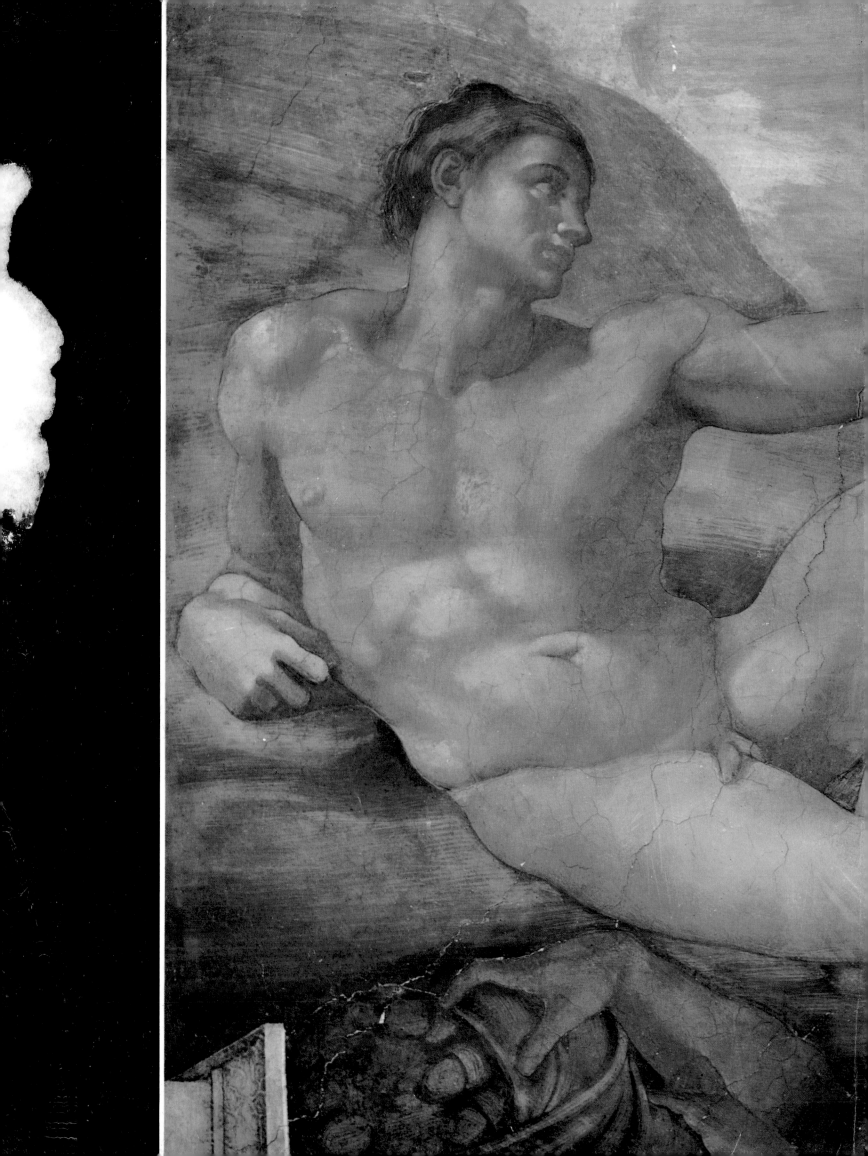

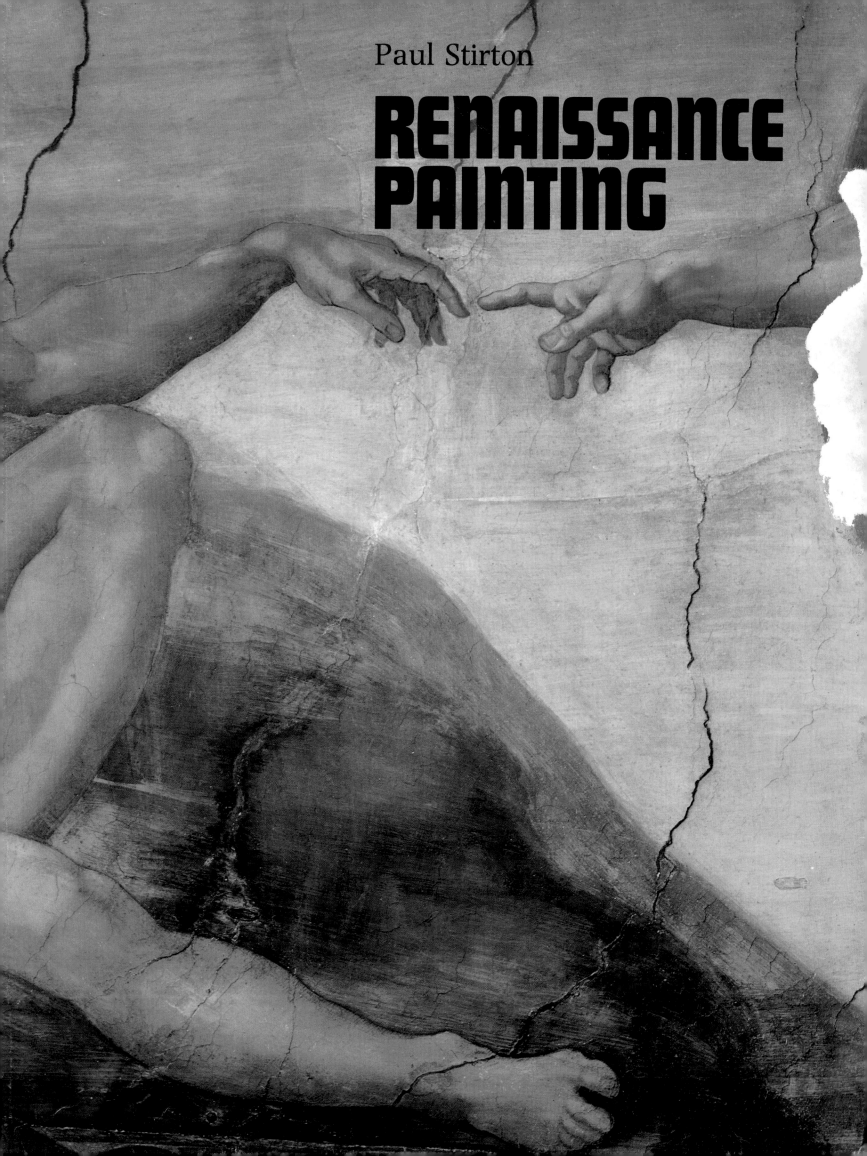

Paul Stirton

RENAISSANCE PAINTING

The quotation from Vasari on page 5 is taken from
Giorgio Vasari: *Lives of the Artists*, translated from the
Italian by George Bull. Penguin, 1965.

OVERLEAF **Michelangelo**: *The Creation of Adam* (detail), 1510–12

PHAIDON PRESS LIMITED

Littlegate House, St Ebbe's Street, Oxford

First published 1979
© TEXT 1979 Phaidon Press Limited
© DESIGN 1979 Heraclio Fournier, S. A.

The film positives of the illustrations are
the property of Heraclio Fournier, S. A.

British Library Cataloguing in Publication Data

 STIRTON, PAUL
 Renaissance painting. – (Phaidon gallery).
 1. Painting, Italian
 I. Title
 759.5 ND611

 ISBN 0-7148-1986-7
 ISBN 0-7148-1921-2 Pbk

Filmset in England by SOUTHERN POSITIVES AND NEGATIVES
(SPAN), *Lingfield, Surrey*
Printed and bound in Spain by HERACLIO FOURNIER SA, *Vitoria*

Raphael: *The Madonna of the Goldfinch,*
107 × 77cm, 1507

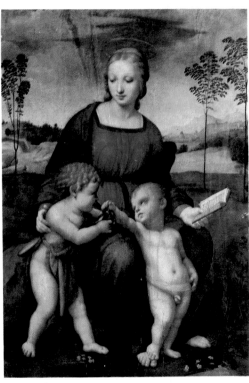

Renaissance Painting

The flood of misfortunes which continuously swept over and submerged the unhappy country of Italy not only destroyed everything worthy to be called a building but also, and this was of far greater consequence, completely wiped out the artists who lived there. Eventually, however, by God's providence, Giovanni Cimabue, who was destined to take the first steps in restoring the art of painting to its earlier stature, was born in the city of Florence, in the year 1240.

IN THESE OPENING LINES to the life of Cimabue, the sixteenth-century writer and artist, Giorgio Vasari, confidently asserts the beginning of something, which he refers to elsewhere as a *rinascita*, or Renaissance: a rebirth of the art and ideas of the ancient world which had lain submerged throughout a thousand years of barbarism and disorder. At least, that is how Vasari interpreted it. He traced the progress of this 'Renaissance' over three centuries, seeing its development mirrored in the life of a man, from childhood, through youth to a glorious maturity in the work of Michelangelo.

It seems a very simple interpretation, the kind which provokes the scepticism of modern historians. This view, however, expressed by Vasari in a series of artists' lives, has dominated the popular notion of the Renaissance to this day. Why should this be? In an age of particular historical awareness, when the idea of artistic progress is in decline, we still cling to the pattern of Vasari's account. One reason is that Vasari's system has had such a profound influence on our ideas that our view of the past depends upon it. After all we still use the term 'Middle Ages' when referring to the period between Antiquity and the Renaissance, implying that it was little more than an interlude. In this sense, we are seeing the Renaissance through Vasari's eyes. We classify the artists of the time according to his three periods and we have adopted his prejudices when looking at their pictures. We are still inclined, for example, to see Cimabue's work in terms of later developments in Italian art despite the overwhelming visual evidence of its similarity to contemporary Byzantine pictures. Vasari was at pains to emphasize the debasement of earlier art, and especially the 'clumsy awkward style' of the Byzantines, so as to support his view of a miraculous rebirth at the hands of the Florentines. This interpretation cannot stand in the face of the evidence provided by our knowledge of fourteenth-century Italian society.

The flow of trade, emigrants, ideas, and artefacts from the Levant to Italy can be traced without interruption from the decline of Rome until long after the Renaissance. It saturated the country with a Byzantine influence which permeated all areas of art and life and, far from being debased or mean, it was the driving force behind the cultural life of the Mediterranean countries. This was particularly true at

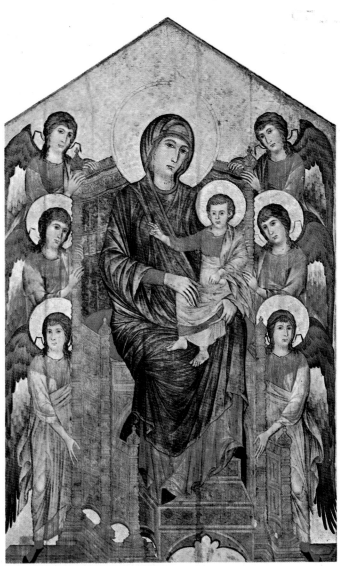

Cimabue: *The Madonna with Angels,* 424 × 276cm

Page 6. **Cimabue:** *Virgin in Majesty*, 385 × 223cm, c.1285
Page 7. **Giotto:** *Ognissanti Madonna*, 325 × 204cm, 1308

Cimabue's *Virgin* for the church of Santa Trinita and Giotto's *Ognissanti Madonna* are equally monumental in scale, but there is a marked contrast in the way that each artist treats the subject. Cimabue's work depends on the conventions of Byzantine art and as such is primarily a two-dimensional image on the surface of the panel. There is some indication of depth in the throne, but it is counteracted by the vertical emphasis of the design, which places the angels one above the other. Giotto's picture on the other hand employs a completely new visual language where, despite the gold background, there is a clearly recognizable space within the picture, and at least the implication of a ground plane. Surface decoration and ornament have given way to an exploration of physical form and its structure, so that the Madonna is presented as a solid individualized figure.

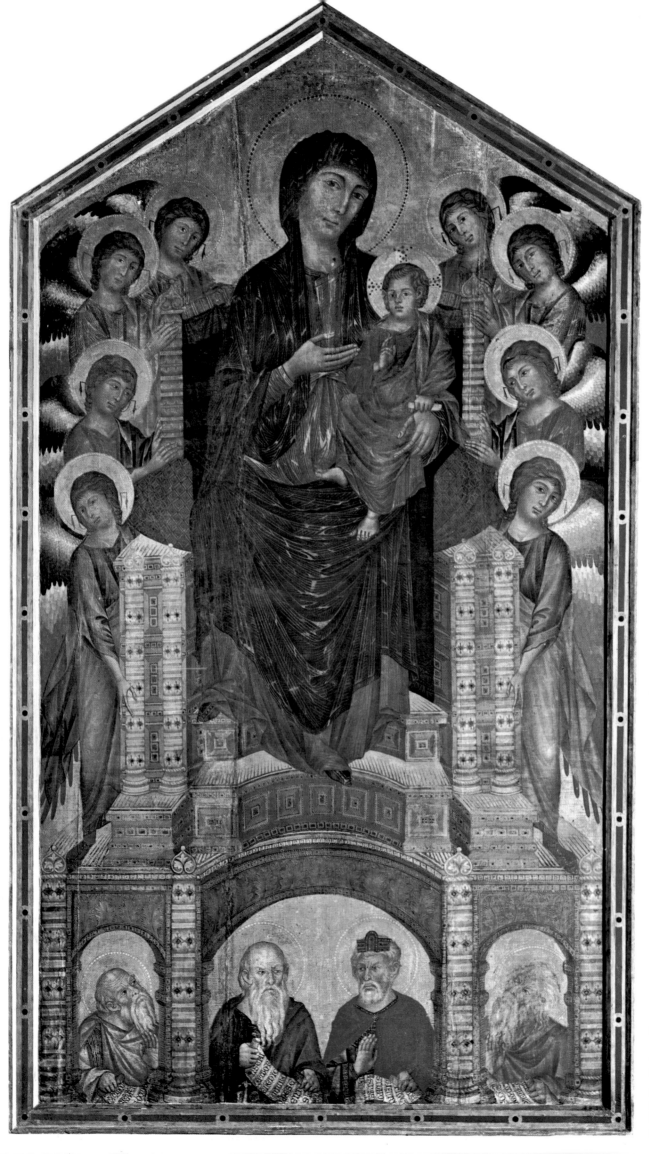

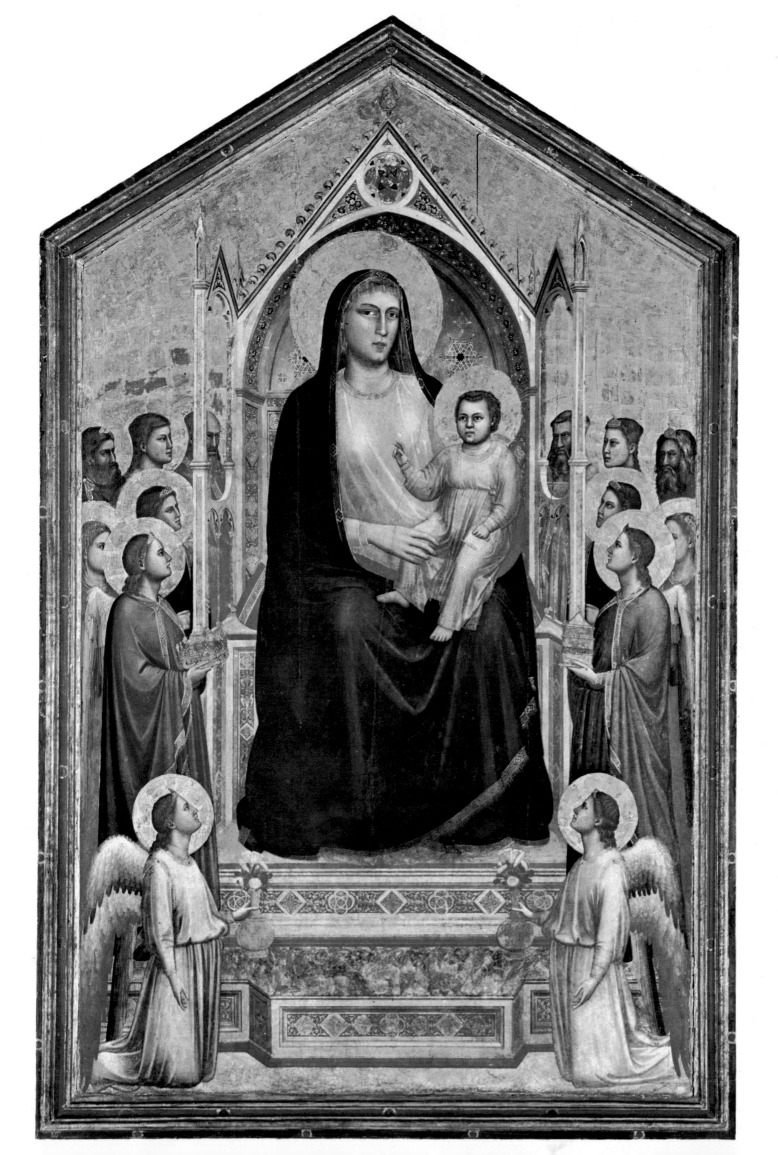

the time of Cimabue because the Empire of the Paleologi was undergoing a brilliant last artistic flowering. Indeed the 'humanization' of Christan dogma grew out of the Eastern church. Meditation on the wounds of Christ and on the sufferings of the Virgin, which were first recommended by the Greek Fathers, formed the basis for the popular religion of St Francis of Assisi. Monks from his order travelled and preached throughout Italy, bringing the people into closer contact with the church and clearing the way for a new religious art.

In Florence the response to this can be seen in the work of Giotto, the central figure in the first part of Vasari's *Lives* and an artist whose fame was celebrated by Dante even during his own lifetime. To modern eyes a painting like the *Ognissanti Madonna* may still seem to be cast in a traditional mould, but this is simply the overall format which was governed by certain guidelines. When the picture was painted in the early fourteenth century, it would have

Giotto: *The Return of Joachim to the Shepherds,* c.1305

The liveliness of Giotto's naturalistic style is especially evident in the early scenes in the Arena Chapel. These episodes from the story of the Virgin's parents, Joachim and Anna, and from the early life of the Virgin were probably taken from the 'Legends of the Saints' or, as it came to be known, 'The Golden Legend', a collection of apocryphal tales by the theologian Jacobus de Voragine. With its simple language and vivid narrative it was immediately popular after its completion in the 1260s, and a perfect source for Giotto's work. In this scene Joachim is returning to his flocks in the hills after being expelled from the temple because he is old and childless. The dejection of the old man, oblivious to the greeting of the dog, and his nervous reception by the shepherds are perfectly conveyed by the simplest of means.

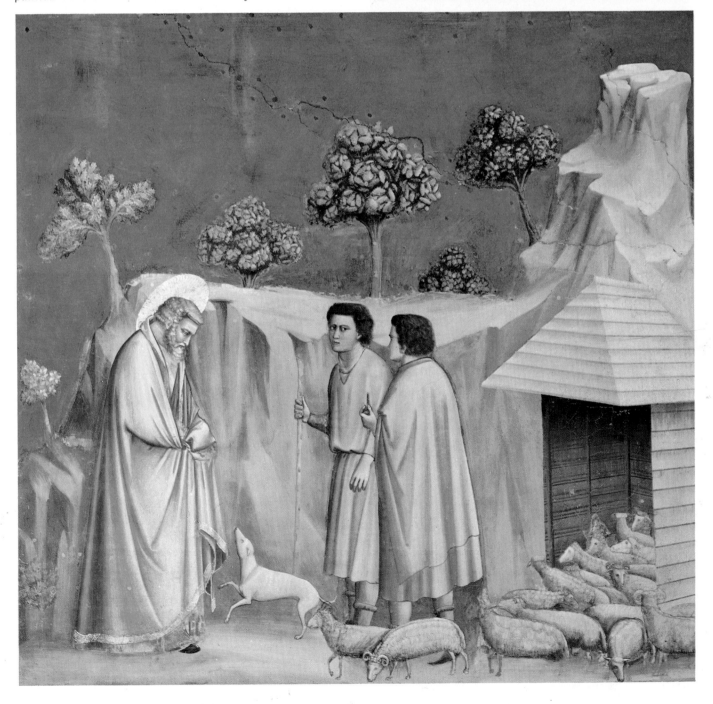

OPPOSITE **Giotto:** *St Francis* (detail), c.1300

9

appeared as a fairly radical departure from the earlier style because Giotto's Madonna shows the first signs of the monumentality and realism which remained a permanent asset of Tuscan art. The contrast provided by Cimabue's Madonna for Santa Trinita represents the difference between the existing Byzantine tradition in Italy and the new native style based on Byzantine, Gothic and indigenous elements. The sources of Giotto's art lie in the majestic frescoes of Cavallini in Rome and the dynamic figural sculpture of Nicola Pisano, and from this he has created a new artistic reality of form and space. The Madonna has a physical presence, and the altarpiece drew the spectator into a completely new relationship with a devotional image. Instead of an emblem or sacred form, hallowed by centuries of worship, it became a source of contact with Christ and the Virgin on a distinctly human level, and the change which it incurred forced a complete reappraisal of the traditional forms and techniques of painting. For Giotto himself the full extent of these innovations was realized in the large fresco cycle in the Arena Chapel in Padua.

Duccio: *The Virgin and Saints,* 42·5 × 34·5cm. c.1300

Unlike French Gothic architecture with its preponderance of stained glass, Italian churches had few windows and relied upon mural paintings of biblical stories both for decoration and instruction of the largely illiterate population. The Arena Chapel is rather unusual in that it was designed specifically to receive a large fresco cycle, so the architecture itself is of secondary importance. The interior is a simple chamber with high walls, and on this Giotto has represented a narrative sequence of thirty-six scenes from the lives of Christ and the Virgin. As with most Tuscan art of this period, there are precedents for the subject matter and iconography in the late Byzantine art of the Macedonian school, but Giotto's interpretation has such a profound humanity and directness as to mark the beginning of a new era in the history of art. Each scene, although part of the narrative, is completely individual and self-contained, and Giotto has managed to maintain this balance by focusing on a particular moment in the story which can be encapsulated in a drama of personal human contact. The representation of events and emotions appears, in fact, to be entrusted to a range of eloquent gestures and subtle glances, and everything else in the picture, including the composition, plays a minor role. Even the landscape settings which should be the most significant development, since they are giving the scenes a natural location, perform their function admirably while being no more than roughly blocked out masses. Against this, the personal Christian story is abstracted to one of permanent and universal significance. In short, the importance of Giotto's art can be said to reside in the fact that the depiction of men and women, in a simple but ordered environment, had become the primary subject in painting. In Siena, the new spirit was translated into a completely different form to that of Florence. Sienese commercial links were strongest with the Levant, and the large Eastern communities in the city ensured that there was a market for the artists and artefacts, scattered across the Mediterranean with the decline of Constantinople. It is understandable, therefore, that Duccio, the pioneer and master of the Sienese school, should adhere much more closely to the forms of Byzantine art. His madonnas appear to follow the pattern of hundreds of small icons which had been brought into Italy over the previous century. But Duccio models the faces of his figures with a delicacy that preserves the refinement of the picture while introducing the sensation of distinctly human emotions. Furthermore his colours, although not descriptive in the manner of Giotto, do not directly follow Byzantine conventions. Their brilliance is part of an autonomous harmony which operates purely within the picture itself. In view of this, it cannot be said that Duccio was the last supreme example of the 'Greek manner' in Tuscany, precisely because his work does not employ the fundamental symbolic principles of that art. He has combined with the Byzantine elements a confident and precocious assimilation of a purely Western idiom, which sets his work apart. This idiom can be recognized in the decorative serpentine line characteristic of Northern Gothic art, which he could have derived either from the work of French miniaturists or even from the flowing rhythms of Giovanni Pisano's sculpture. He certainly must have seen examples of Giovanni's work because the sculptor had a workshop in Siena for the last twenty years of the thirteenth century. This feeling for line

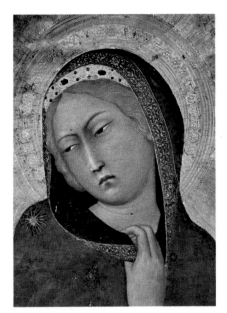

LEFT **Simone Martini:**
The Annunciation (detail),
1333

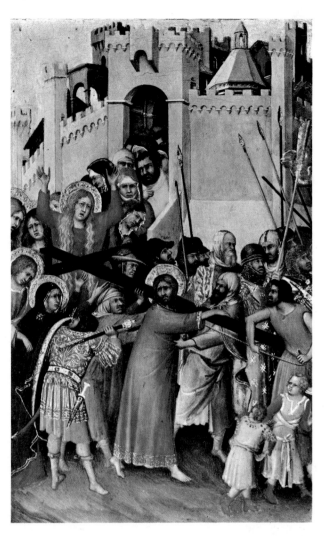

softens and animates the broad areas of Duccio's colour and,
in the gold border of the Virgin's robe, it takes on a lyrical
identity of its own which carries the eye around the com-
position.

These qualities of line and colour were the characteristics
which sustained Sienese art for over half a century, and they
remained prominent features in the work of Duccio's fol-
lowers. They also made their work more adaptable to formal

Simone Martini: *St Louis,* 200 × 138cm, 1317

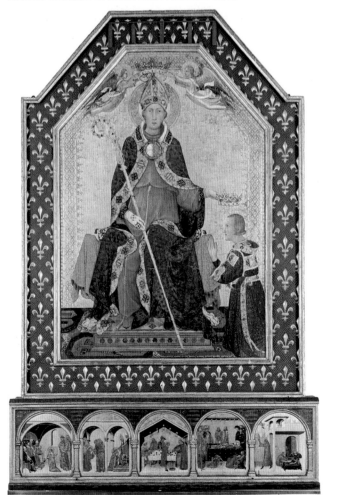

qualities in other styles. As a result Sienese artists found their
work in demand throughout western Europe, securing for
them the kind of reputation that brought a wider range of
stimulating sources than were available to the followers of
Giotto. This success also increased the influence of Sienese
art on later developments in the North. While the feeling for
line in Gothic art had helped to free Duccio from the Byzantine
figurative tradition, for Simone Martini it became a primary
source of inspiration. Simone's *Annunciation* preserves the
spirit of Duccio in its rich colour and the rhythmic flow of
the silhouette, but the rather mannered elegance of the
Virgin's pose comes from a Northern model. As with Byzan-
tine art, Vasari tended to dismiss Gothic as a crude and
barbaric style, and in the later Renaissance many Italians
used the term as one of criticism or abuse, but there was a
regular traffic in Gothic ivories and miniatures from France
which exerted a profound influence on Italian artists. In fact,
the shift of emphasis from the spiritual to the physical world
was initiated by the naturalistic impulse of Gothic art.
Simone probably saw mature Gothic work quite early in his
career when he was employed by the court of the French
royal family in Naples, but the full importance of his work
was realized after 1339 when he was invited to work in the
Papal Palace at Avignon. Backed by the universal prestige of
the Papal court, his style was enriched by cosmopolitan in-
fluences and disseminated throughout Europe, to form the
basis of the International Gothic style which flourished later
in the century.

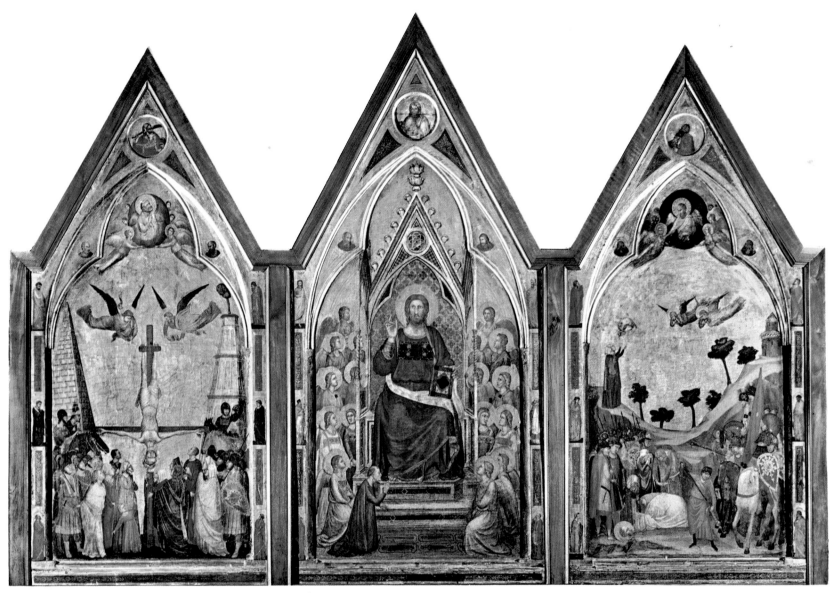

Giotto: The Stefaneschi Altarpiece (front)

Ambrogio Lorenzetti, on the other hand, was the only artist to attempt a synthesis of the most progressive elements in Sienese and Florentine art. The measure of his success can be seen in numerous small madonnas where the colours and form are held in a balance which combines the deepest spirituality with a delicate warmth of human feeling. Any hope that this would engender a mature Tuscan style in the second half of the century, however, was dismissed when Ambrogio and his brother Pietro died in the plague of 1348.

After a series of bad harvests and economic failures the Black Death, which had ravaged Europe, decimated the populations of Florence and Siena, and the survivors emerged, cowed and bewildered, in a society which had retreated from its earlier prosperous position. The confidence bred from economic prosperity was shattered, and the influx of peasants from the countryside made it impossible to restore the progressive outlook of the previous few decades. The best example of this can be found in the tenor of religious life which was now dominated by the Dominicans. The mystic St Catherine of Siena replaced the popular Franciscan preachers, and the strict severity which was imposed on public worship changed the whole character of religious art. Instead of the humanity expressed in the solid confident form

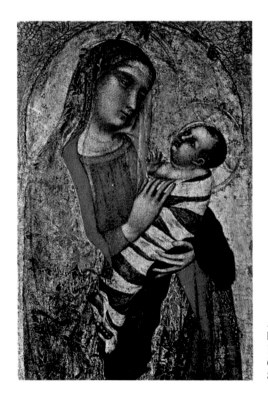

Ambrogio Lorenzetti: *The Virgin and Child,* 57 × 85cm, c.1340

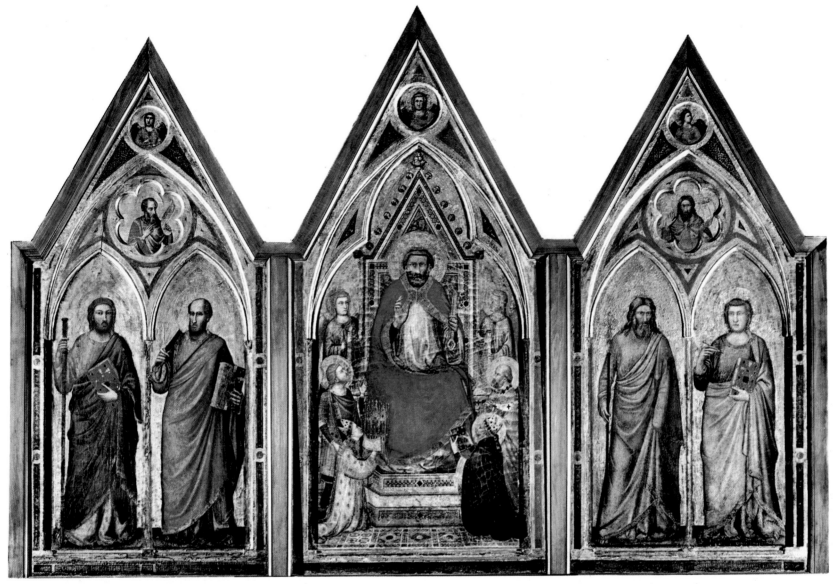

Giotto: The Stefaneschi Altarpiece (back)

of the *Ognissanti Madonna*, artists turned to the stiff, hieratic figures of the Stefaneschi Altarpiece, a latent, secondary style within the canon of Giotto's large studio. But, although it can be traced back to the studio of Giotto, the ascendance of this style meant that the first phase of the Renaissance had effectively finished, and the threads remained to be picked up in the early years of the next century.

In the fifteenth century or 'Quattrocento' we can be said to have arrived at the Renaissance proper. Here, for the first time, there is a body of ideas and knowledge which justifies the word 'rebirth'. Vasari sees the first stirrings of this in the city of Florence, and, although he was notoriously biased towards his native city, there is some justification for his view.

From the twelfth century onwards, Florence had the advantage of the most highly developed economy of all the Italian city states. Traditionally, the textile industry had been the basis of this wealth, but by 1400 Florentine fortunes were restored by the commercial and banking concerns of the major families. Florence had become the banking centre of Europe, with agents and offices in every major city collecting an interest which sometimes ran as high as 100 per cent.

Giotto: Stefaneschi Altarpiece, central panel 178 × 88cm, side panels 167 × 82cm, c.1330

Giotto received several important commissions from Cardinal Stefaneschi, including this great altarpiece painted for the high altar of St Peter's. The central panel represents Christ in majesty surrounded by angels, while at the foot of the throne kneels the donor in adoration. The side panels represent the crucifixion of St Peter and the decapitation of St Paul. The brilliant architectural conception of the throne has all the confidence of the master, but some aspects of the painting — the stiff, hieratic poses, the vivid colours and the irregular proportions of the figures — seem far removed from the Giotto of the *Ognissanti Madonna*. This has led many critics to dismiss it as the work of an assistant, but in the large workshops of the fourteenth century, when artistic personality was not understood in the narrow sense of the individual, it was possible for a single artist to have several variations of style.

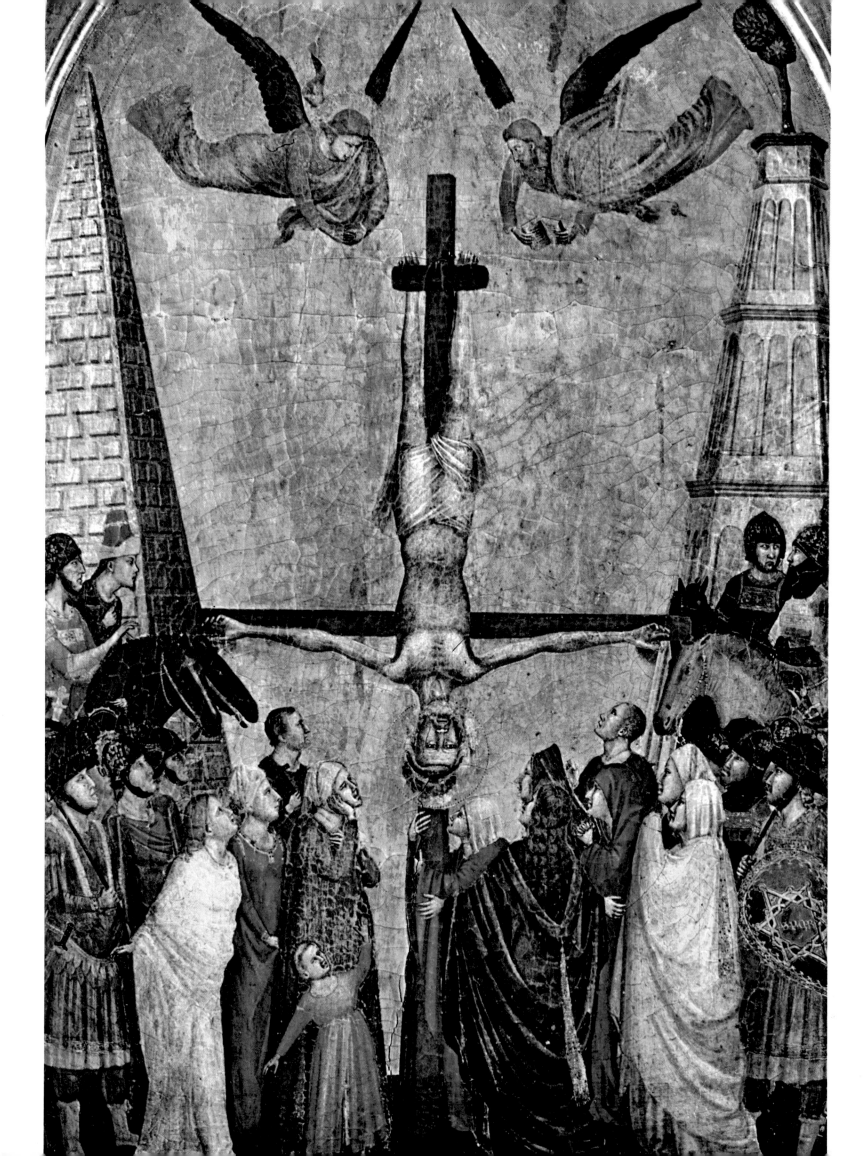

From this income a whole class of patrons evolved, with a new outlook and lifestyle. It was this new 'urban bourgeoisie', with its energy and spirit of enquiry, which provided the finance and much of the scholarship behind the serious revival of antiquity. They set up collections of antique gems, libraries of Latin and Greek manuscripts, instituted a new programme of education for their children, and, most important of all, patronized a small group of classical scholars known as 'humanists'. The importance of these humanists was that they saw and interpreted the classics of antiquity with a contemporary significance. They identified Florence with ancient Rome as the champion of republicanism, an identification which gathered momentum among the Florentines as the threat to the city by the feudal Lord Gian Galeazzo Visconti of Milan increased. The intense civic pride that developed was directed into a public display of the superior achievements of Florentine artists and craftsmen. Merchant guilds undertook grand building schemes, including the completion of the immense dome on the cathedral, and assumed the responsibility to maintain and adorn different churches throughout the city. It seems unusual that a movement with secular origins should express itself through the church, but the popular religion remained dominant, and most serious art was commissioned for religious contexts. Churches provided a centre for the rich families to display their generosity in atonement for the sins of their prosperity, and this gave works of art an almost unprecedented significance, and artists vied with each other to excel in the eyes of a sympathetic public. In this atmosphere it is easy to understand the kind of popular celebration which attended the unveiling of famous paintings or sculptures such as the bronze doors for the Baptistry of Florence, and to appreciate the part they played in the religious life of the city. This was definitely a kind of forcing house where new ideas took root and matured in a relatively short period of time. The new spirit was first evident in sculpture. Sculpture was, after all, an obvious civic art form with a precedent in ancient Rome. It was also more expensive, and, by the same token, more prestigious for the patron. Consequently, the desire to emulate the three-dimensional quality of sculpture may have encouraged painters to model their figures in light and shade and thereby suggest a sense of volume. But to explain the rational development of pictorial space, which is the primary characteristic of early Renaissance art, solely in these terms would be to overlook the role that the practice of perspective played as act of knowledge at the very centre of humanist art.

Vasari and numerous other commentators relate how perspective was discovered by the architect Filippo Brunelleschi. What this probably means is that he perfected a system employing a single vanishing point which would give the impression of a space within the picture receding into the distance. The discovery was not intuitive or accidental. As an architect and humanist, Brunelleschi was well versed in antique thought and especially Euclidean geometry. He most likely achieved his results through a series of calculations based on the measurements and ratios between objects at varying distances from the eye. In other words, he sought to explain the order of visual experience within the rational systems of ancient mathematics. The same process can be seen at work in his buildings, where the logic of the

parts is instantly recognizable because they employ pure geometric shapes laid out in simple ratios. Squared pavements and lines of regular columns and arches all impose a mathematical order on the space enclosed by the building.

The importance of this breakthrough can be seen in the work of Masaccio, the first in a long tradition of great Florentine artists of the Quattrocento. Apart from the fact that he seems to have gone back to Giotto for the simplicity and massive weight of his figures, the *Trinity* fresco demonstrates the principles of Brunelleschi's perspectival system in practice. Masaccio has even used the forms of Brunelleschi's architecture to indicate the lines of recession. Unfortunately, an illustration cannot communicate the extent of the illusion. The vanishing point is placed at eye level when the viewer is standing in front of the fresco so that the real space of the church interior appears to continue into the picture. It is as if the Holy Trinity with the Virgin and St John have appeared in a small chapel at the side of the nave to reveal the everlasting truth of the resurrection.

The Trinity and the series of frescoes by Masaccio in the Brancacci Chapel were to act as the model for Florentine artists in the coming century. However, this new art had to make its way against the established taste for the style known as 'International Gothic'. All general historical terms

Spinello Aretino:
*St Nemesius and
St John the
Baptist*, 194 ×
94·5cm, 1385

Masaccio: *The Trinity,* c.1427

Masaccio: *The Adoration of the Magi,* 21 × 61 cm, 1426

are to certain extent misleading, but, taken at its broadest definition, the sources of this style lay in the final expression of Northern Medieval art. The difficulties arise when one considers how widespread and diverse the style was, because it had been carried throughout Europe by itinerant artists and craftsmen. In this way, a style which reflected the richness, elegance, and playfulness of courtly life could be found as readily in Spain or Bohemia as in Paris and Dijon. Its greatest exponent in Italy was the painter Gentile da Fabriano, and an indication of his success can be seen in the famous *Adoration of the Magi,* commissioned by the wealthy

patrician and nobleman, Palla Strozzi. It was very costly in an obvious way, but patrons and artists alike were completely overwhelmed by the richness and diversity of the work, and its effect was such that echoes of the composition and style could be found in Florentine paintings thirty or forty years later. The relevance of this lies in the fact that the Strozzi altarpiece was painted in the same city and in the same decade as Masaccio's *Trinity* and yet the two pictures are obviously poles apart in matters of style. Gentile has attempted to give the figures a sense of volume in the modelling of the heads, but the fantastic costumes are the focal

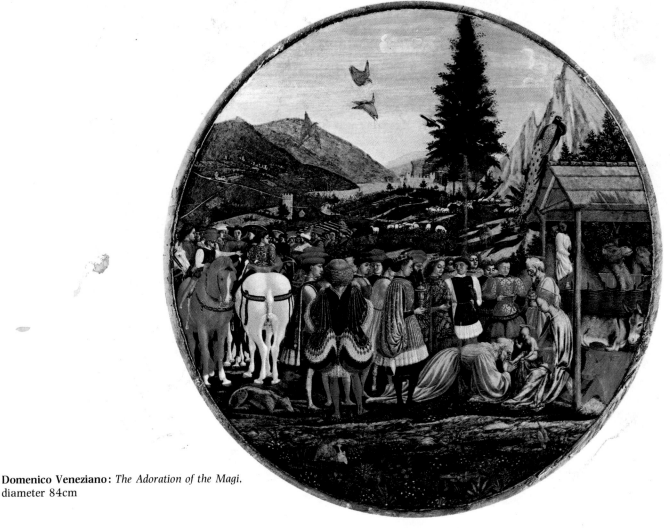

Domenico Veneziano: *The Adoration of the Magi,* diameter 84 cm

17

LEFT **Masaccio
and Masolino:**
*The Virgin, Child
and St Anne.*
175 × 103cm.
c.1424

RIGHT **Masolino:**
*The Assumption of
the Virgin.* 142 ×
76cm. c.1428

RIGHT **Gentile da Fabriano:** *The Virgin
Enthroned with Two Saints.*
131 × 113cm. 1390–5

point for a brilliant display of decorative patterns. This alone
is enough to cast Masaccio's figures into extreme relief and
to emphasize the way in which the restrained colour em-
bodies their solid sculptural quality.

Much as the two styles are markedly different, they did
not exist in later Florentine art as opponents. Rather they
should be seen as alternatives which artists felt able to
exploit depending on the nature of their commission. This
partly explains the many equivocal elements in the paint-
ings of Masaccio's immediate followers, artists who would
be considered as the torchbearers of the new enlightenment.
Masolino, for example, embraced elements of the new style

LEFT **Bonifacio
Bembo:** *St Julian.*
28 × 85cm. c.1460

OPPOSITE **Gentile da Fabriano:** *The Adoration of the Magi* (detail), 1423

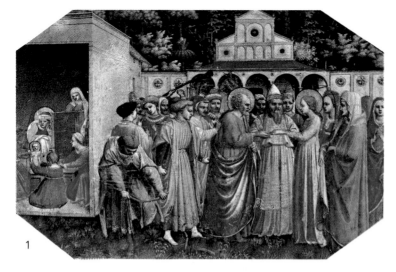

1 **Fra Angelico:** *The Annunciation*: The Marriage of the Virgin

2 **Fra Angelico:** *The Annunciation*: Mary and St Elizabeth

3 **Fra Angelico:** *The Annunciation*: The Adoration of the Magi

4 **Fra Angelico:** *The Annunciation*: The Presentation of Jesus in the Temple

5 **Fra Angelico:** *The Annunciation*: The Death of the Virgin

BELOW **Fra Angelico:** *The Annunciation* (detail)

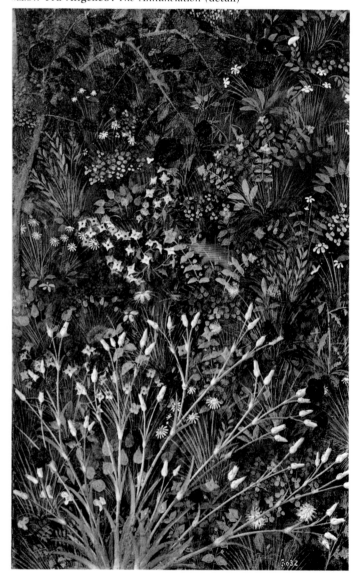

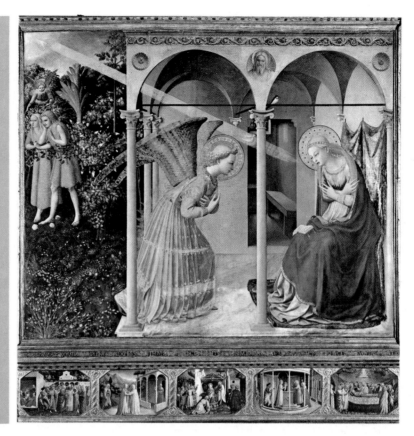

Fra Angelico: *The Annunciation*, 194 ×
194cm, c.1430

This *Annunciation*, one of several versions of
the subject from the studio of Fra Angelico, is
a good example of the type of altarpiece that
Italian artists of the Quattrocento were com-
missioned to paint. As a result of the growing
interest in pictorial space the polyptych with
several individual but related panels was
gradually replaced by the single large panel
that could represent holy figures or an event
from the scriptures in a unified setting. In this
case the architectural forms of the loggia
that define the perspective still echo the three
leaves of the traditional triptych, but the space
within the picture is continuous in all parts of
the scene. The interpretation and significance
of 'The Annunciation' are extended to the five
smaller pictures of the predella at the base of
the altarpiece. These represent the Birth and
Marriage of the Virgin, the Visitation, the
Epiphany, the Purification in the Temple and
the Death of the Virgin.

while working in the Brancacci chapel, but reverted to his
original Gothic manner after Masaccio's death in 1428. Fra
Angelico, an artist often dismissed as 'sweet' or pious, had
assimilated the lessons of Masaccio's work early in his career.
In the *Annunciation*, the space within the picture is clearly
articulated by architectural forms of a distinctly Renaissance
type, yet the garden from which Adam and Eve are being
driven confounds the perspective by presenting a flat decor-
ative pattern. This contrast between two different approaches
to pictorial representation is even more marked in the work
of Uccello, whose passion for the study of perspective became

something of a byword. According to Vasari, his wife com-
plained because he stayed out of bed at night working on
his experiments. Uccello's most famous pictures amply
demonstrate the work which has gone into laying out the
composition along clearly defined principles. The pattern of
figures and lances in the *Battle of San Romano* follows a grid
of lines which radiate from the vanishing point in the centre
of the scene, constantly reminding the viewer of the logical
system that creates the illusion of space within the picture.
Uccello has even depicted a figure on the ground in dramatic
foreshortening as a demonstration of his skill in the tech-
niques of the new style. But for all his knowledge of the
principles of perspective and their rigorous application,

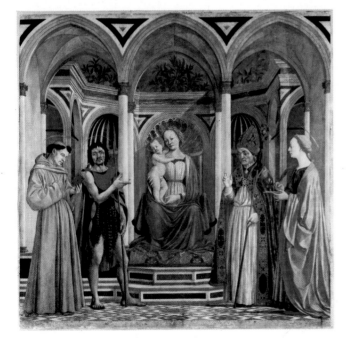

Domenico Veneziano: *The Virgin, Child and Saints*, 209 × 213cm.
c.1445

Pages 22–3, 24 (detail) and 25.
Uccello: *The Battle of San Romano*, 1454–7

These three panels are first mentioned in an inventory
of 1492, which records that they were hung in the
bedchamber of Lorenzo de' Medici. Uccello's
decorative treatment of the battle would be in keeping
with such a domestic location, but this should not be
seen to diminish the importance of the subject. The
history of Florence in the fifteenth century, like that of
all the Italian cities, is punctuated by a series of wars
against neighbouring states, and the exploits of the
army provided good propaganda material for the
republic. The battle itself was a relatively minor
incident in the war against Siena in 1432, but the
Florentine commander, a condottiere called Nicola da
Tolentino, became a very popular figure and the
subject of a monumental equestrian portrait in the
Duomo.

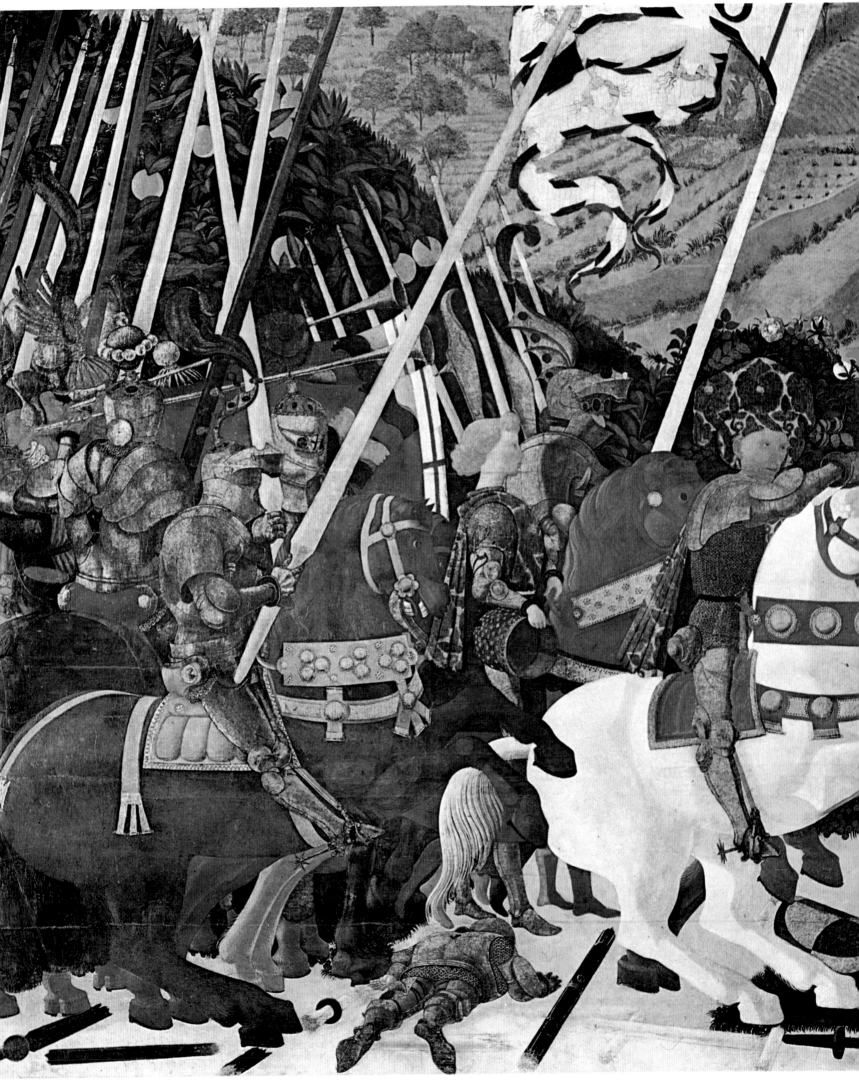

Paolo Uccello: *The Battle of San Romano.* 183 × 319·5cm. 1454–7

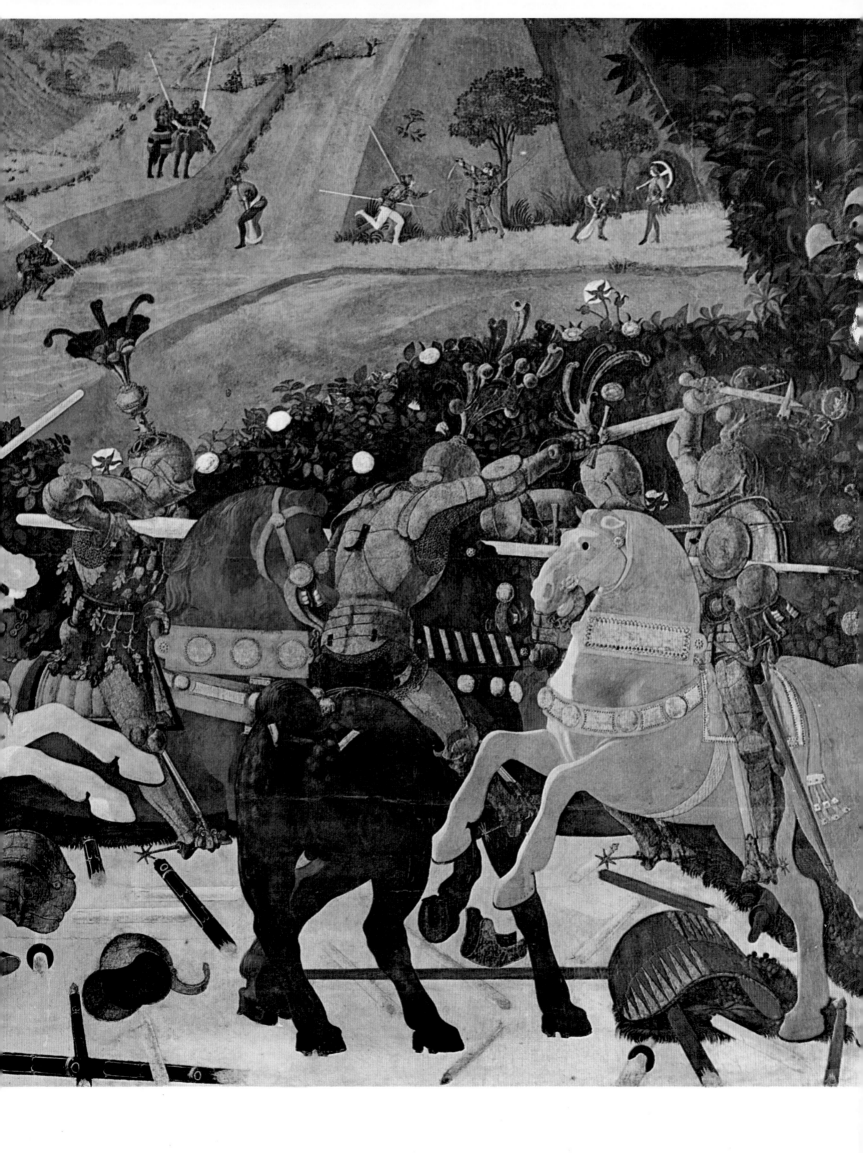

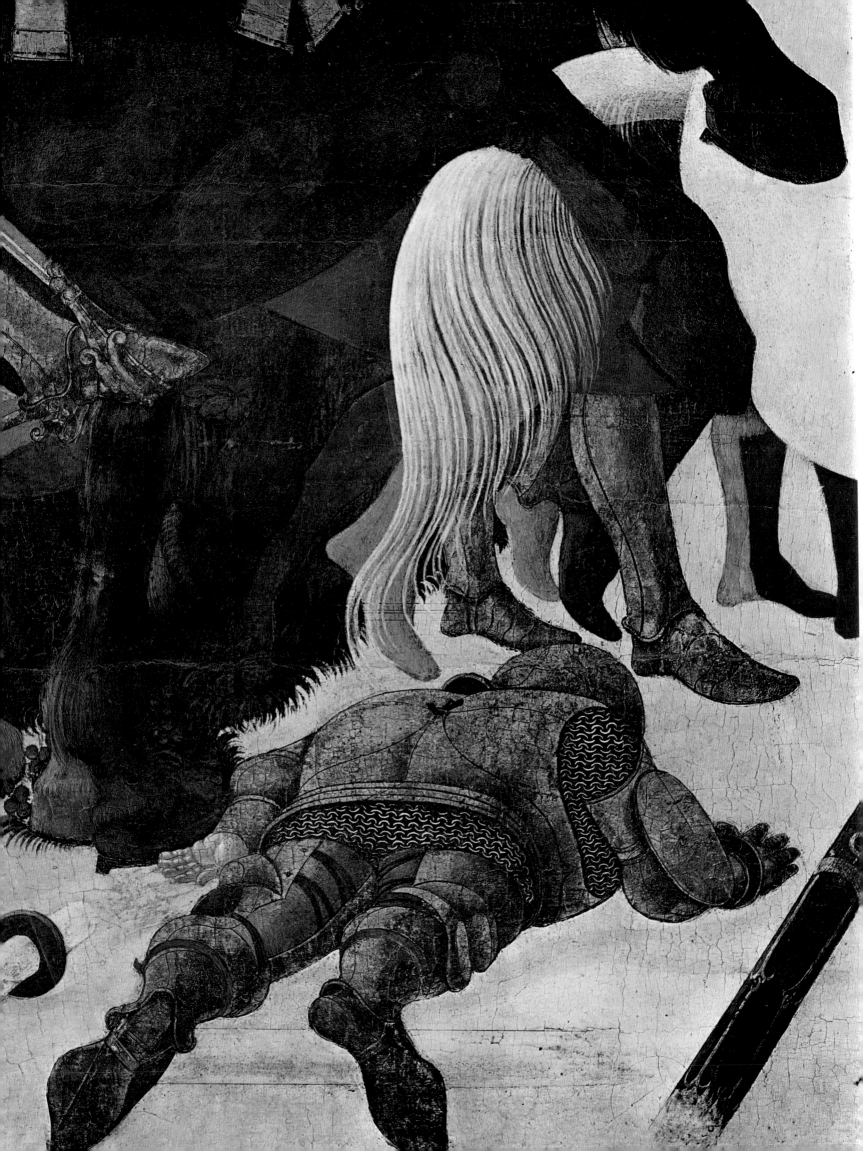

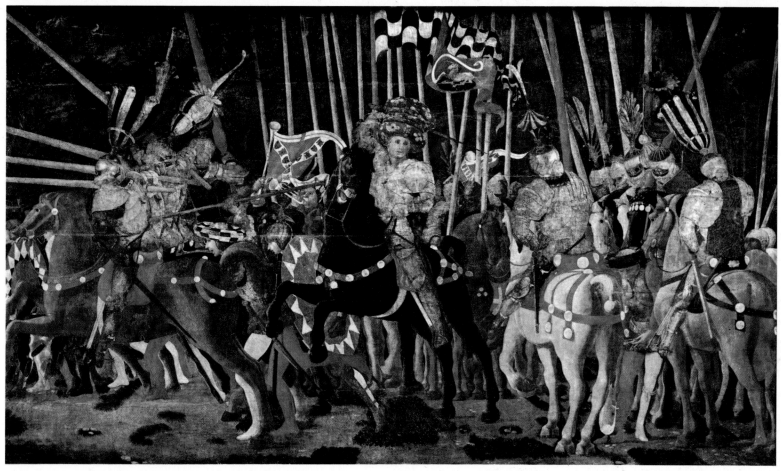

Paolo Uccello: *The Battle of San Romano*, 180 × 316cm, 1454–7

Paolo Uccello: *The Battle of San Romano*, 182 × 323cm, 1454–7

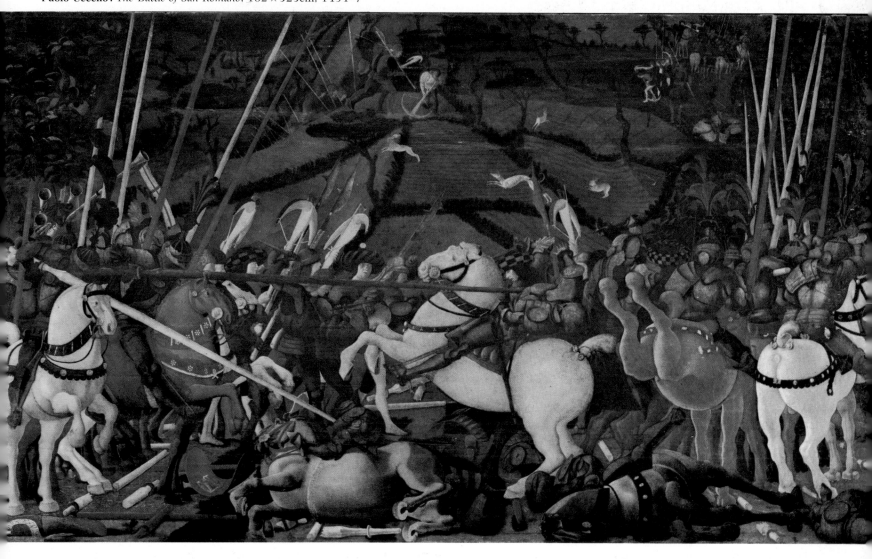

OPPOSITE **Paolo Uccello:** *The Battle of San Romano* (detail)

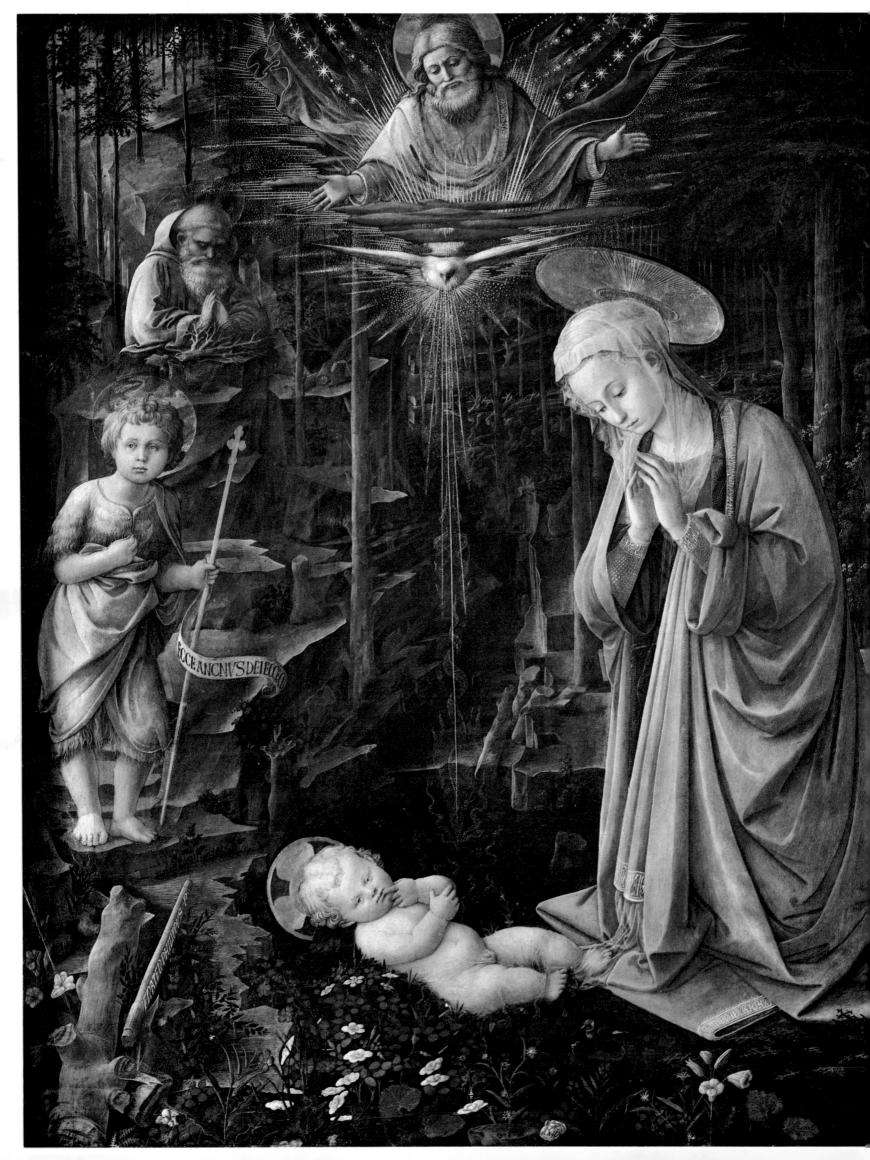

Fra Filippo
Lippi: *The
Virgin and
Child with
Angels* (detail)

Fra Filippo Lippi: *The Madonna
Adoring the Christ Child,*
127 × 116cm, c.1460

Although the most important
works of the early Florentine
Renaissance were intended for
public display, the rise of a new
class of patrons and the secular
life-style that they established led
to an increasing number of com-
missions for small altarpieces to be
placed in a domestic setting or
private chapel. Such pictures were
highly regarded and, being outside
the domain of the church itself,
often permitted greater freedom in
the depiction of religious subjects.
Fra Filippo Lippi, one of the lead-
ing artists of the Quattrocento,
supplied many pictures for this
market, and the small panel of the
Virgin adoring the Christ Child
was painted for his best patrons,
the Medici. In the inventory of
1492, it was recorded as being the
altarpiece of the family chapel in
the Palazzo Medici-Riccardi in
Florence.

Uccello's figures and horses are like models on a stage.
Details, like the richly brocaded hat of the central figure, and
the unnatural colour scheme give the painting a heraldic
appearance as if it was a game or tournament. This accumu-
lation of detail and the reference to the chivalric way of life
immediately recalls the work of Gentile. The same contra-
diction is evident in many pictures, since artists could readily
adopt perspective as a pictorial device without necessarily
appreciating the body of ideas which lay behind it. It became
the hallmark of the new Renaissance style, and both patrons
and painters wanted to be associated with it. Pictures were
now the subject of humanist discourse as well as being
religious artefacts with a devotional purpose. The 'Renais-
sance man' was required to discuss the qualities of paintings
and to differentiate in matters of style as well as to read
Latin, dance, write poetry, and play a musical instrument.
So paintings became increasingly more complex and subtle.

Piero della Francesca is the true heir to Masaccio because
he was primarily concerned with matters of form and space.
But his work shows a deepening of the interest in mathe-
matics, the theoretical background to the new art. As one of
the 'Liberal Arts', mathematics was included in the range of
studies necessary for a humanist education, and the scholars
and princes of the Renaissance took great pride in all their
intellectual accomplishments. Knowledge of Pythagoras
was, therefore, quite widespread among the educated
classes, and Pythagoras's view that mathematics provided a
reflection of the harmony underlying the natural world must
have commanded a great deal of respect. 'Harmony' is the
appropriate word in this context because music was thought
to contain the proof of this essential theory. The notes on the
scale which we use, and which were used in the Renaissance,
can be plotted as the different lengths of a string (plucked
like a lute or a guitar) in a progressive ratio of simple whole
numbers. In this way the beauty of music could be inter-
preted as a series of variations on the basic ratio. One can
understand that this staggering discovery made people

believe that they had found the key to the order of existence. Moreover, since it was a ratio of simple numbers it could be measured, and therefore applied to proportion in architecture and painting alongside that other divine aesthetic, the 'Golden Section'. Piero, more than any other artist of the Quattrocento, became involved with these problems (he later wrote three mathematical treatises), and his pictures are often composed on mathematical principles. This is what gives the allegory of the *Flagellation* its profound mystique and the Brera Altarpiece its sense of portentous deliberation. Perspective, which began as a device to represent the physical world, had become the instrument of creating an abstract world of pure logic and perfect proportion.

Piero is also one of the last artists who could be described as a direct follower of Masaccio since the character of Florentine humanism changed during the second half of the century. The Platonic Academy had developed in Florence and had encouraged the early humanists, but under Ficino and Pico della Mirandola it tended towards a mystical 'Neo-Platonism' that laid more emphasis on the contemplative than the active life. So instead of the spirit of enquiry which had sought to explain the world in rational terms, the new

Piero della Francesca: *The Flagellation*, 59 × 81·5cm, c.1456

Interpretations of *The Flagellation* by Piero are legion, but there is no doubt that the proportion, the composition and the action have some allegorical significance. No other kind of interpretation would justify the prominence of the three figures on the right while the religious event is relegated to the background. A local tradition in Urbino, where the picture was painted, identifies these three figures as Count Oddantonio flanked by the two wicked counsellors whose unpopular decrees were responsible for the revolt in 1444 in which the count was assassinated. If this is the case the picture may have been commissioned as a votive offering to the count's memory by his stepbrother Federigo da Montefeltro, who succeeded him and may have had a hand in the revolt. Another suggestion, which seems slightly more credible, is that the panel symbolizes the difficulties suffered by the Church after the fall of Constantinople to the Turks in 1453.

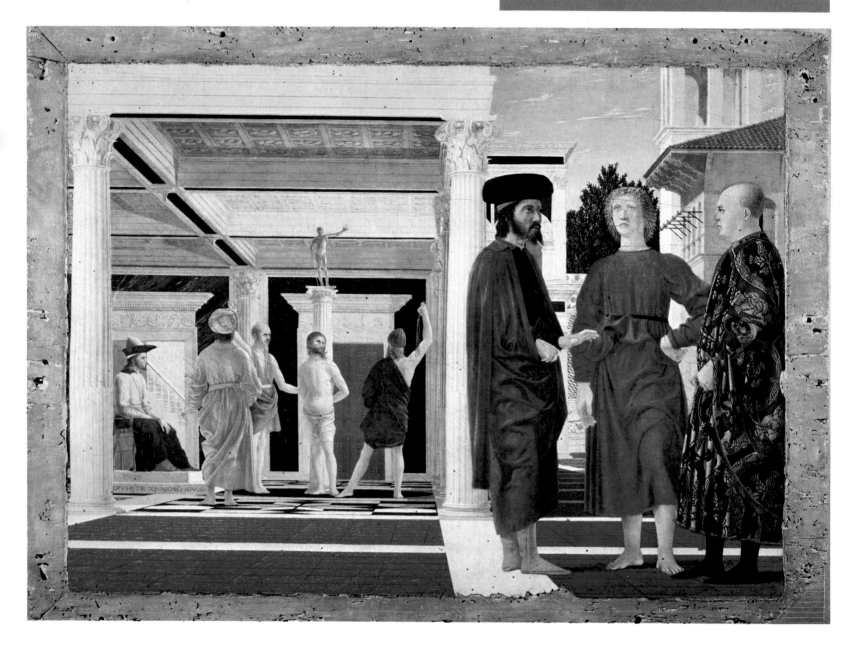

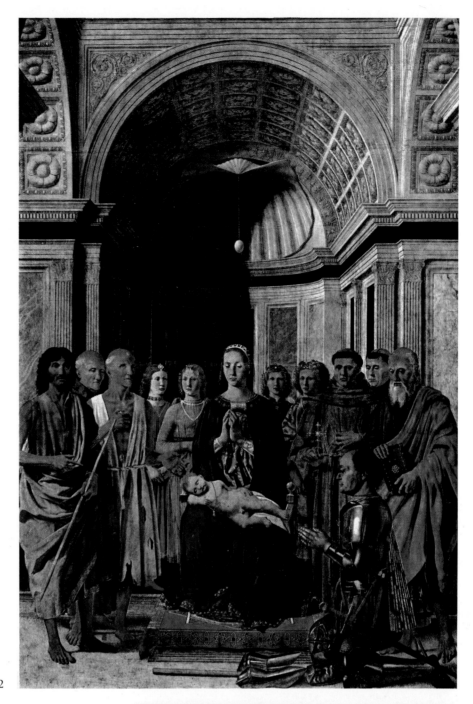

Piero della Francesca: *The Virgin and Child with Angels and Saints*, 170 × 248cm, c.1472

humanists indulged in sophisticated conceits to display their knowledge of antique culture. This contrast is evident in the difference between Cosimo de Medici and his grandson, Lorenzo, as patrons of art. Cosimo had secured the fortunes of the family by discreet political manipulation and he appreciated that his reputation could be enhanced by the prestige that was attached to famous works of art. So to preserve his popular support he employed the leading artists on public as well as private commissions. Brunelleschi, Donatello, Fra Angelico and Fra Filippo Lippi all benefited from his patronage, and some of their finest work was only made possible by the scope of his activities. Lorenzo 'il Magnifico', on the other hand, contrary to popular opinion, was a noticeably poor patron of the fine arts, preferring books and decorative objects. His palace was a haven for writers and intellectuals, and he himself was a highly educated man, but he sought to emulate the courtly life of an earlier aristocracy, and the nature of his humanism changed accordingly. The poems, songs, and paintings created for his elite group conceal their meaning behind a cloak of allusions which are indecipherable to the uninitiated. Sandro Botticelli was the painter most closely associated with this circle, and his allegories

Overleaf **Piero della Francesca:** *Federigo da Monte-feltro, Duke of Urbino, and his wife, Battista Sforza,* each 47 × 33cm, 1465

Federigo da Montefeltro, who commissioned these portraits of himself and his wife from Piero della Francesca, was one of the most remarkable and cultured rulers of the Quattrocento. Although his lands were comparatively modest and isolated, he was able to maintain a court of humanists and artists in the palace at Urbino from the money he earned as a leading condottiere. The artists, Uccello and Piero, and the architects, Laurana and Francesco di Giorgio, all worked for him, wealthy Italian families sent their children to be educated in the palace, and the manners of the court were recorded by Baldassare Castiglione in his book, *The Courtier*, which set the pattern for refined and polite behaviour throughout Europe. But Federigo's most remarkable achievement was the library he created with the help of the bookseller, Vespasiano da Bisticci. Virtually the whole corpus of classical literature and philosophy known at that time was represented, and, as Vespasiano pointed out, 'not a single page is wanting from their works in so far as they are in themselves complete; which cannot be said of any other library.'

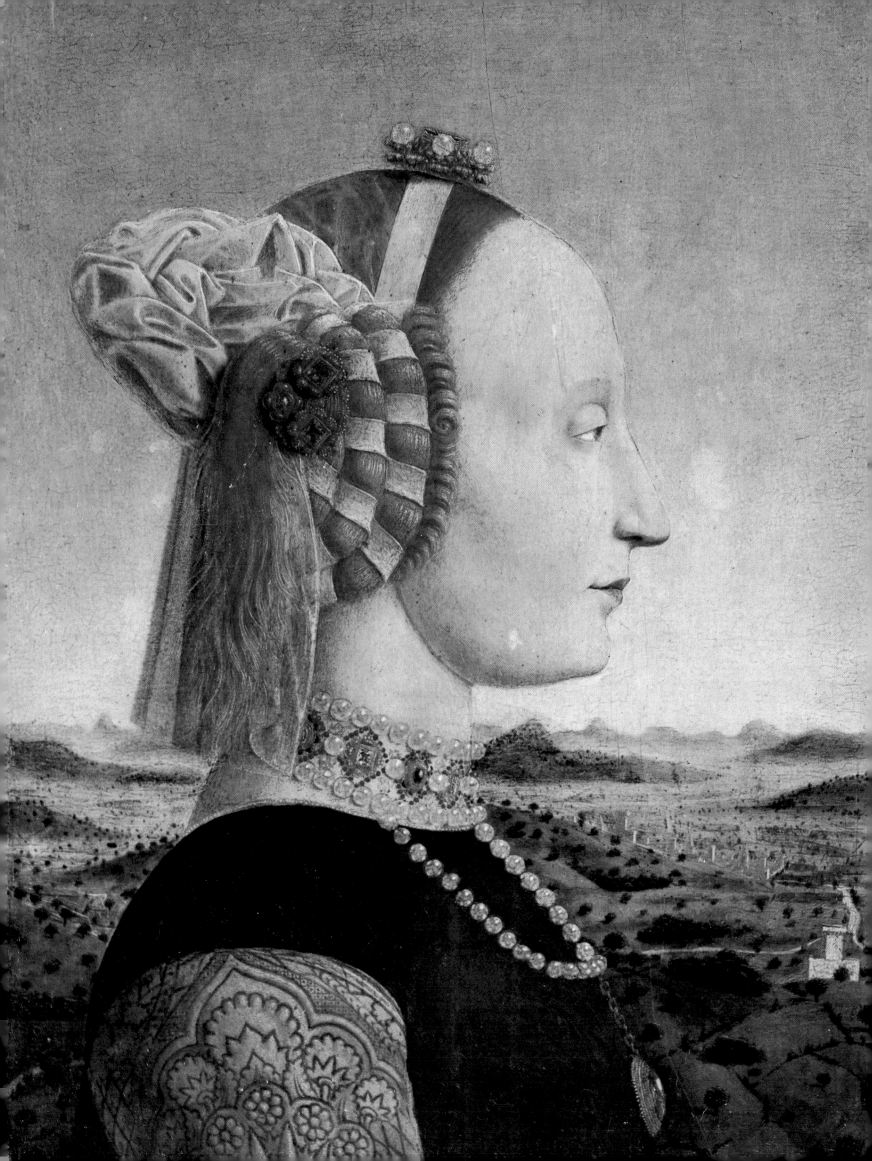

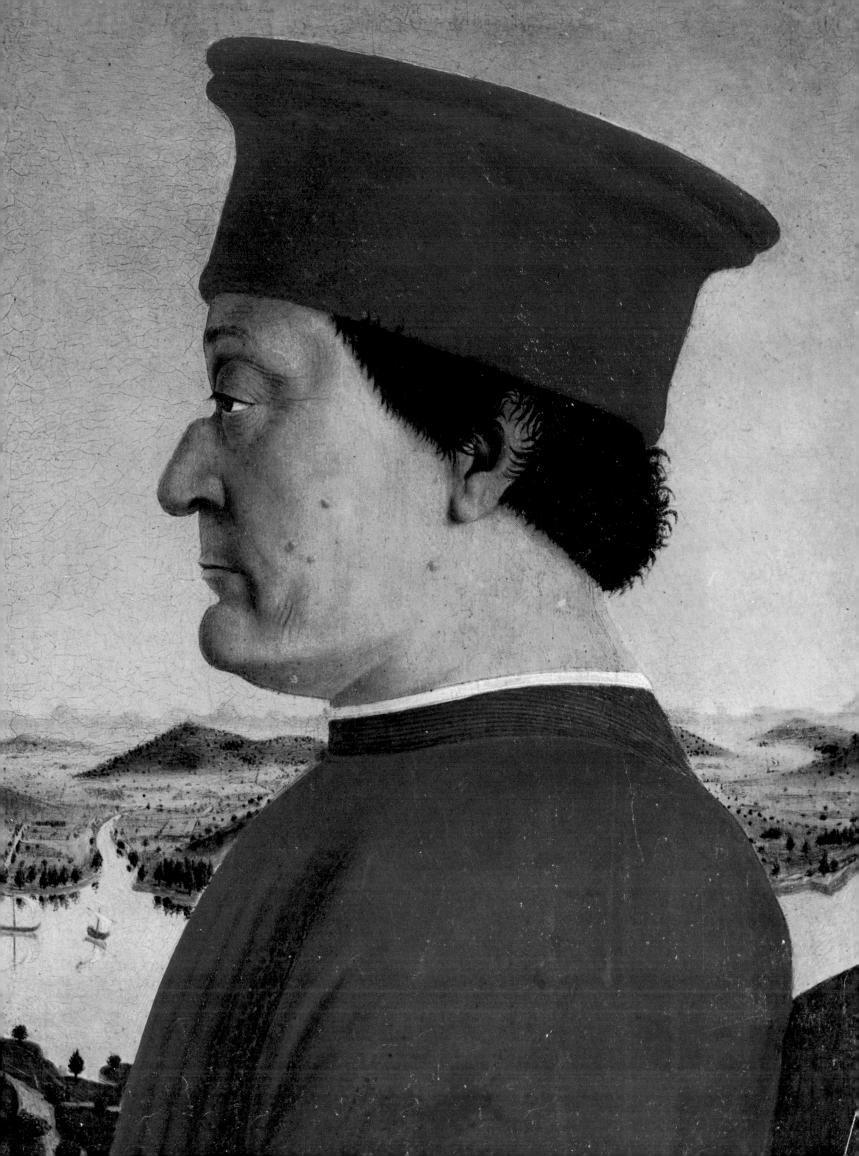

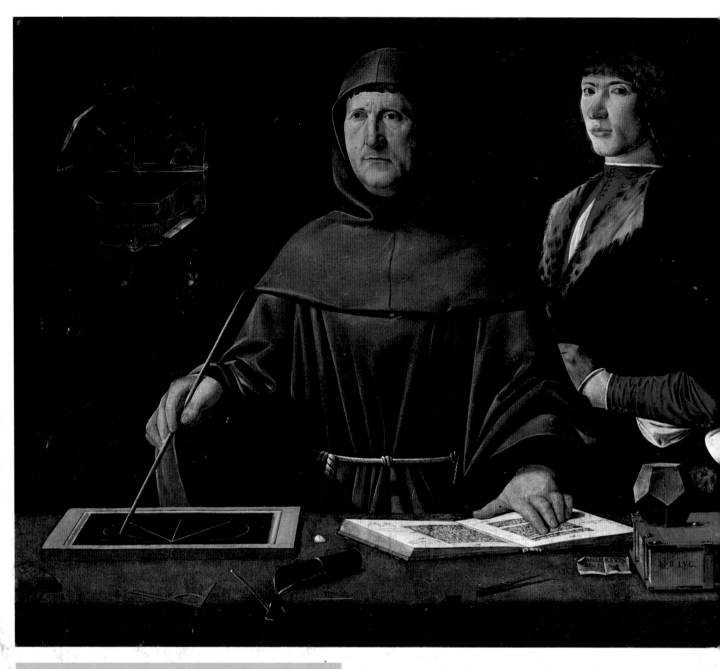

Jacopo de' Barbari: *Portrait of Luca Pacioli,*
99 × 120cm, 1495

Fra Luca Pacioli, represented here with one of his
students, was a pupil of Piero della Francesca and
Leon Battista Alberti. From them he learned to admire
the classical ideals of mathematics and perspective, but
he was more concerned with the theoretical side of the
subject than with any direct application in the fields of
painting or architecture. As a result, his most famous
book, *De Divina Proportione*, published in 1497, is
largely Pythagorean and mystical in its approach and
thus found a sympathetic reception in the Neo-
Platonic circles of the late fifteenth century. Neverthe-
less, Pacioli's friendship with Leonardo and his
encouragement of the artist to publish his scientific
studies provide a direct link between the artists of the
Early and High Renaissance and affirm the idea of a
certain continuity in the intellectual tradition of
Florentine art.

demonstrate the kind of complex programme that was
drawn up to amuse and educate the young courtiers. The
style of these paintings also revives the art of an age passed
over by Masaccio. *The Birth of Venus* is based on one of the
most famous antique statues, the Venus Pudica, but it is her
linear elegance and not a sense of physical volume which is
communicated in the picture. *Primavera* is peopled by figures
recalling the nymphs and goddesses of antiquity, but they
occupy a glade of pure Gothic fantasy, where the plants and
foliage provide an overall decoration reminiscent of a
tapestry.

The extent to which humanism actually influenced Floren-
tine artists is difficult to assess, and many people have dis-
missed it as an overrated concept. But the work of these
scholars as educators and propagandists was significant.
Their historical writings gave the Florentines a sense of
identity and superiority by linking the city to a spurious
classical heritage which they interpreted in their art and
letters. In other words, paintings and literature became

symbols of the great new age and were celebrated as such. Whether Florentine art was 'superior' in any sense is irrelevant because this pattern of propaganda was so persuasive that it gave Florence a reputation of cultural authority which the other Italian states could only acknowledge or else be thought of as provincial or 'Gothic'. By the mid-fifteenth century, many Italian centres had adopted the ideas and taste of the Florentine bourgeoisie and had begun to collect works of art in the new Renaissance style. Consequently, Florentine artists were awarded major commissions in different parts of Italy, despite the closed shop of the local painters' guilds, and each one left something of the new style to influence the artists of that area.

Uccello, Fra Filippo Lippi, and Castagno all worked in the Veneto during the first half of the century, but the most important factor in communicating the Tuscan style was the sculptor Donatello, who had a workshop in Padua from 1443 to 1453. This prolonged residence ensured that Paduan artists had reasonable experience of the ideas and working methods of a major innovator in Florentine art. As a result, it was one of the few 'provincial' centres which was able to develop its own school. Paduan society was also able to nourish it. There was a university in the city with an

Botticelli: *Primavera*, 205 × 314cm, 1477–8

This picture was painted for Lorenzo di Pierfrancesco de' Medici, a second cousin of Lorenzo the Magnificent, and it is a perfect expression of the complex Neo-Platonism of that circle. The programme was probably drawn up for Botticelli by the poet, Poliziano, as an elaborate commentary on certain passages from classical literature and as such it would have formed part of the young patron's humanist education. Lorenzo would have recognized the scene from Ovid at the extreme right, where Zephyr, the god of the mild west wind, pursues the nymph, Chloris, and, at his touch, she is transformed into the resplendent figure of Flora, the goddess of Spring. Similarly, the god, Mercury at the opposite side dispersing the mists with his wand personifies the arrival of the new season. But the presence of the Three Graces, Blind Cupid and Venus (or Eve) implies that the allegory has a much deeper meaning.

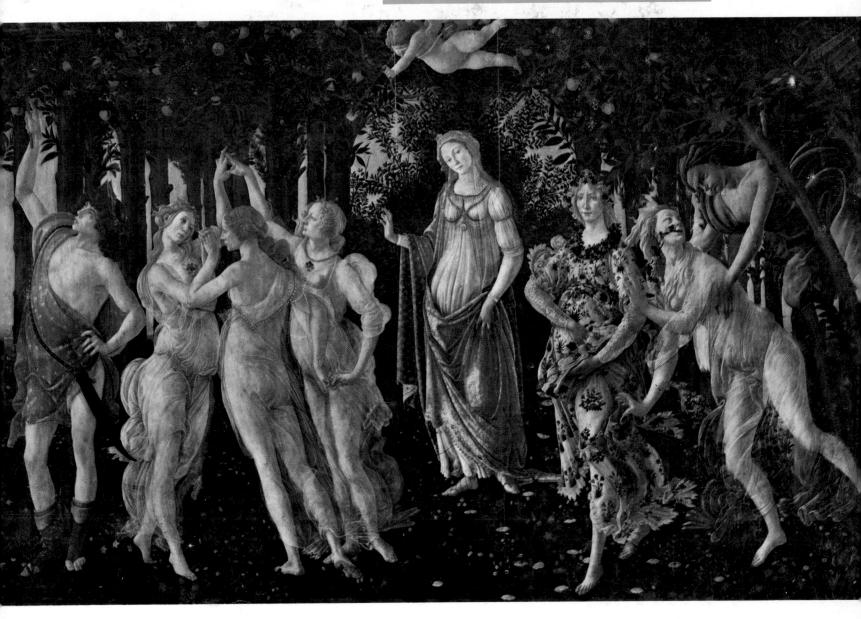

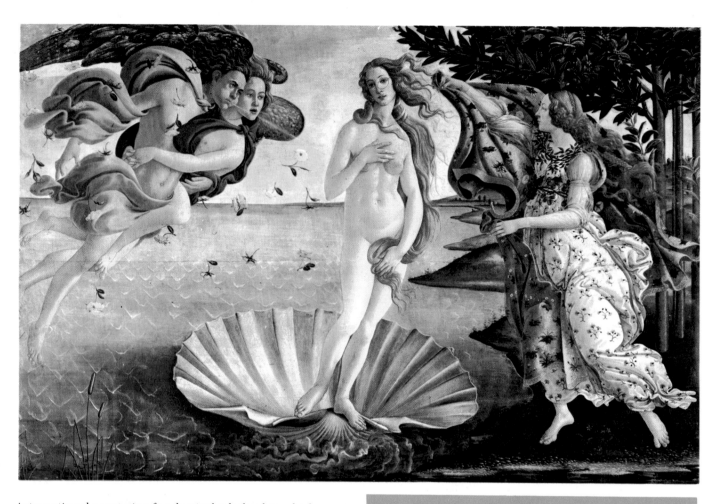

international reputation for classical scholarship which must have prepared the ground for the new art, and the cathedral was a pilgrimage centre for the followers of St Anthony. The style of painting which evolved, therefore, was a curious hybrid, based on a study of Donatello's reliefs superimposed on the local (Venetian) tradition of rich and bright colours. The centre for this was the studio of Squarcione, where a

Botticelli: *The Birth of Venus*, 175 × 278cm, and detail, c.1480

The Birth of Venus was commissioned for Lorenzo di Pierfrancesco's villa at Castello, near Florence, and, like the *Primavera*, it probably owes its inspiration to the Medicean poet, Angelo Poliziano. He had alluded to the myth in which Venus was born from the foam of the sea and then blown to the shore on a scallop shell by gentle breezes. In Botticelli's version the goddess of Love is being received by a nymph, who is about to enfold her body in a richly embroidered cloak. But the picture cannot be regarded as a direct representation of a specific myth or test. Rather Botticelli has sought to reflect the poet's evocative approach to antiquity, transforming the natural world into an ancient poetic memory.

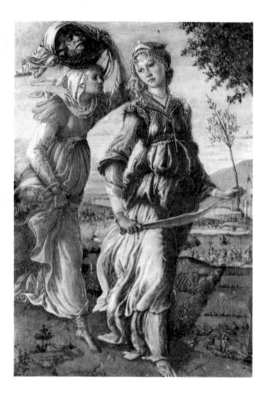

Botticelli: *The Return of Judith*, 31 × 24cm, 1484

whole generation of North Italian artists were trained. He is reputed to have visited Rome and even Greece, but, whether he did or not, the most commonly reported fact about him is that he was a collector of antique casts and fragments, and his pupils were set to copy from them. He certainly had a great many pupils, over 165 according to one estimate, and he seems to have maintained his studio by the dubious practice of formally adopting the most promising assistants so as to retain their services.

OPPOSITE **Botticelli:** *The Birth of Venus* (detail)

Piero di Cosimo: *Mythological Subject*, 65 × 183cm

Piero di Cosimo: *Mythological Subject*
Botticelli: *Venus and Mars*

The large wedding chests called cassoni, in which brides stored their household linen, were important items of furniture in the Renaissance and, as such, were often decorated with elaborately carved mouldings and narrative paintings. Although many of the pictures have been separated from their original chests and are now seen as independent panel paintings, they can usually be identified by their elongated shape and composition. Their major significance, however, was that they provided artists in the Quattrocento with the opportunity to depict secular subjects, usually mythological tales or allegories of love, with a particular relevance to the families concerned. Of the two examples shown here, Botticelli's is the more accessible, being the well known theme of love triumphing over war, as personified by the antique gods, Venus and Mars. Piero di Cosimo's panel is rather more abstruse. This scene of a dead nymph mourned by a faun and a faithful dog was originally thought to show 'The Death of Procris', but this title is no longer accepted.

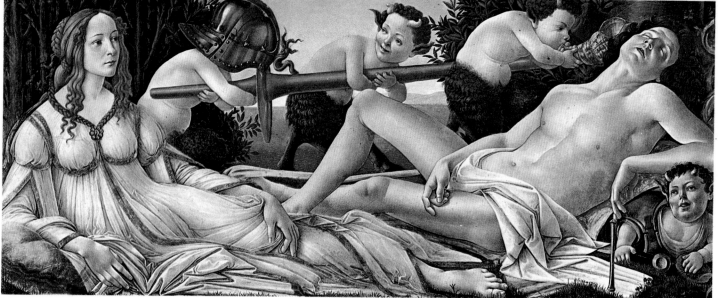

Botticelli: *Venus and Mars,* 69 × 173·5cm, c.1485

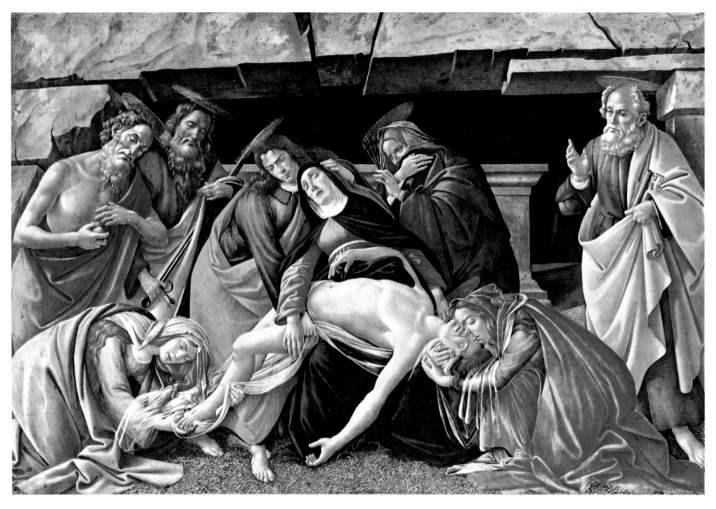

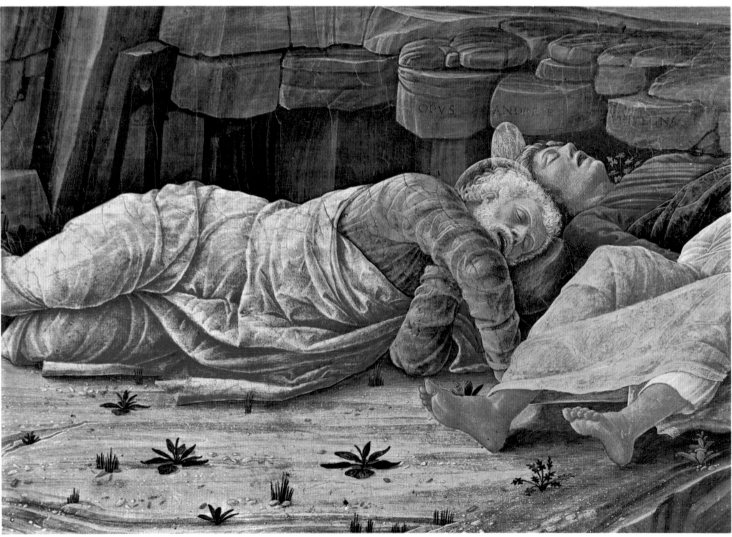

Mantegna: *The Agony in the Garden* (detail)

Opposite **Botticelli:** *Pietà*, 110 × 207cm, c.1495

Botticelli's late paintings strike a note of intense religious fervour, which is not only in direct contrast to his earlier humanist allegories but quite unprecedented in Florentine art of the Quattrocento. This has often been interpreted as the influence of Savonarola's apocalyptic sermons which, according to Vasari, had a profound effect on the artist, and even if it cannot be traced to Savonarola himself, Botticelli's work at this time must in some sense be a response to the political turmoil and uncertainty of the 1490s. In the *Pietà* the tragedy of the scene is emphasized by the wavering composition, the oppressive setting and above all the agonized expressions of Christ's immediate followers. But although this treatment makes a direct appeal to the viewer's emotions the fact that saints Peter, Paul, and Jerome are in attendance suggests that the picture was originally an altarpiece.

Andrea Mantegna, Squarcione's greatest pupil, must have benefited from this training, and he freely litters his paintings with the crumbling fragments of antique buildings. It is a kind of humanistic nostalgia for a glorious age in the past as well as a comment on the continuing presence of the classical tradition in the actual landscape. Mantegna's settings have a similar, dry, monumental appearance, and a sense of scale and structure was already evident in his earliest work. This must be partly due to his dependence on Donatello because no Paduan artist could have communicated such a palpable sense of form at that time. It is the same dependence on sculptural prototypes that gives his art the hard, brittle quality common to the figures and the barren rocky outcrops, and this aspect of his style was extremely influential.

Although Mantegna virtually withdrew from the popular arena after 1459, when he became court painter at Mantua, his early style continued to dominate the work of younger artists and it formed the basis for several minor 'schools' in Northern Italy. Ferrara is the most obvious case in point, and it succeeded in supporting a quite distinct, if slightly mannered, tradition. In this way the principles of Florentine art were transformed into a variety of local types, and the Renaissance spread throughout the peninsula.

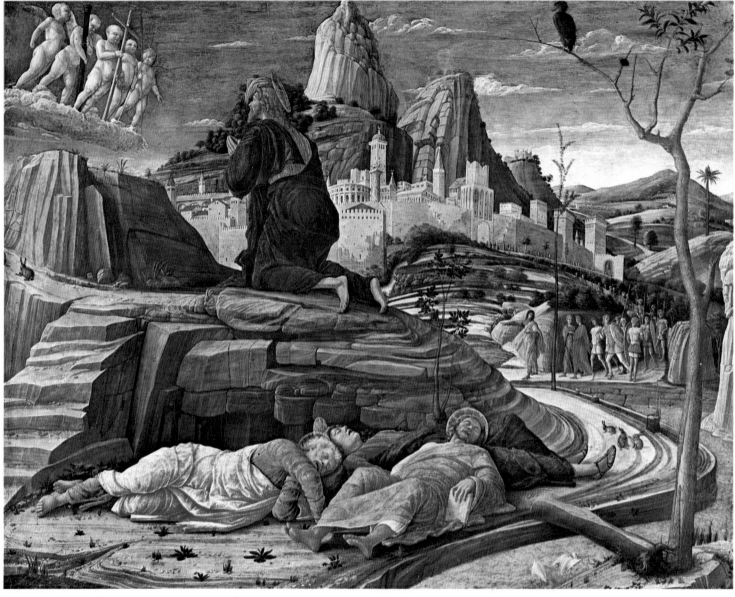

Mantegna: *The Agony in the Garden*, 63 × 80cm, c.1460

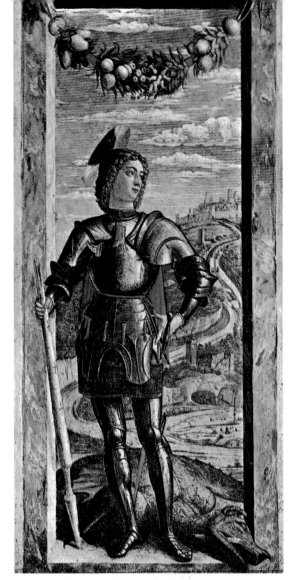

Mantegna: *St George*
Mantegna: *The Crucifixion*

The emphasis on form and design in Mantegna's art is an obvious characteristic of *The Crucifixion*, which was originally the central predella panel on the San Zeno altarpiece in Verona. Here the structure of the composition is based on the simple geometric shapes bounded by the crosses, and the solid conception of the figures is strengthened by a rocky landscape, giving the picture the appearance of a relief sculpture. The fact that this formal aspect could be associated with a revival of antiquity is emphasized by the artist's interest in the armour and accessories of the Roman soldiers, but Mantegna's classicism was not restricted to this. The small panel of St George has no specifically antique details, but the attitude of the figure and its *contrapposto* pose communicate both an air of monumentality and the feeling of calm repose after the struggle, which have subsequently become the popular interpretation of antique statuary. *St George* confirms that Mantegna had a more sophisticated understanding of classical art than any other fifteenth-century artist.

LEFT **Mantegna:** *St George.* 66 × 32cm. c.1460
BELOW **Mantegna:** *The Crucifixion.* 67 × 93cm. 1457–9

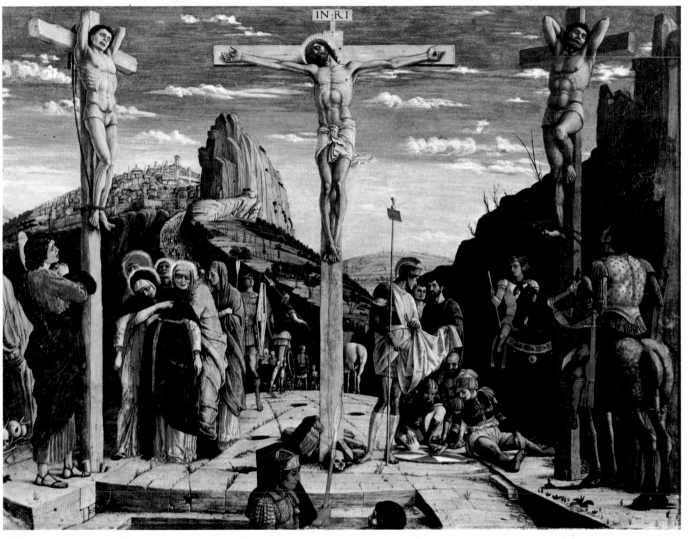

OPPOSITE **Andrea Verrocchio:** *Tobias and the Angel.* 84 × 66cm. c.1470

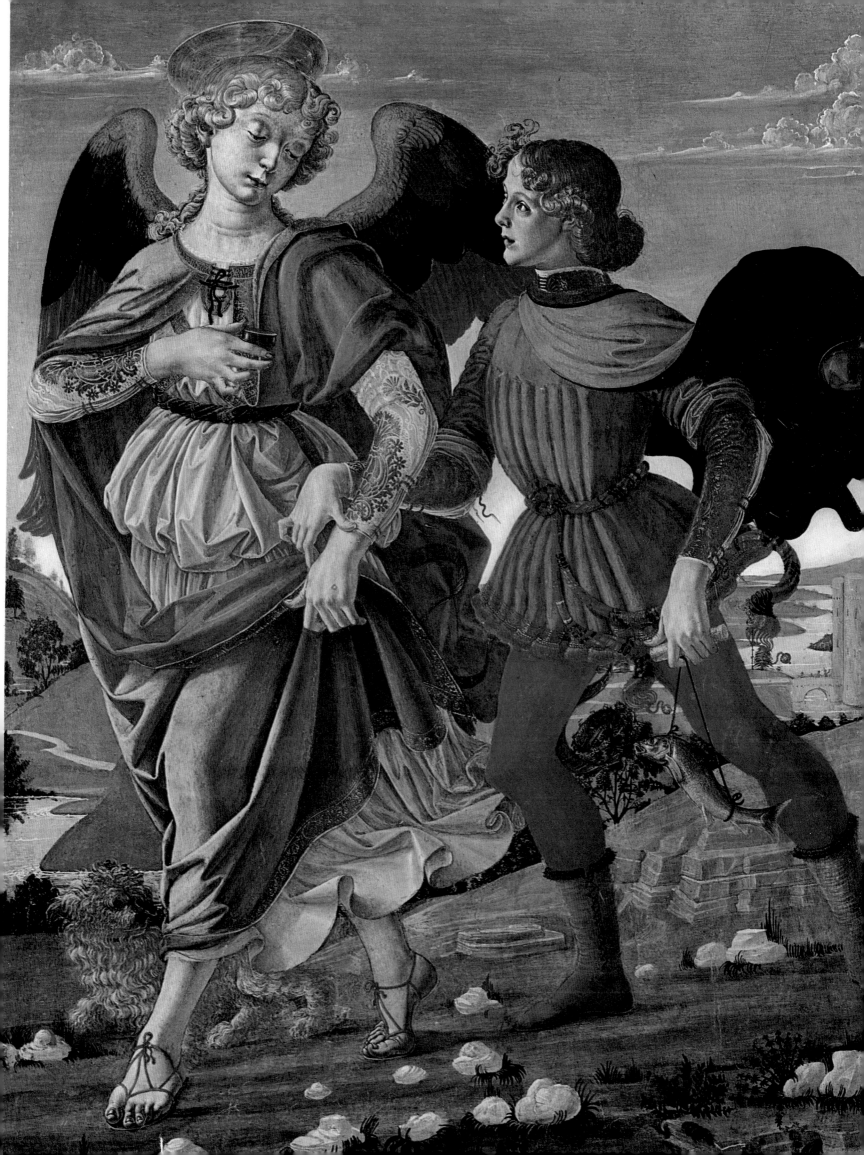

The Renaissance took hold in Venice much later than in other parts of Italy because that rich and powerful city proudly wanted to preserve its cultural independence in matters of art, as in everything else. So the blend of humanism and natural observation emanating from Florence was completely alien to the Venetian school of painting. Even Giotto's work in Padua, which was in their sphere of influence, had virtually no effect. The reason for this is that Venetian art, like the city itself, evolved in a completely different way to that in the rest of Italy.

RIGHT **Crivelli**: *St Mary Magdalene*. 152 × 49cm

LEFT **Cosimo Tura**: *Virgin and Child in Majesty*. 239 × 102cm. 1474

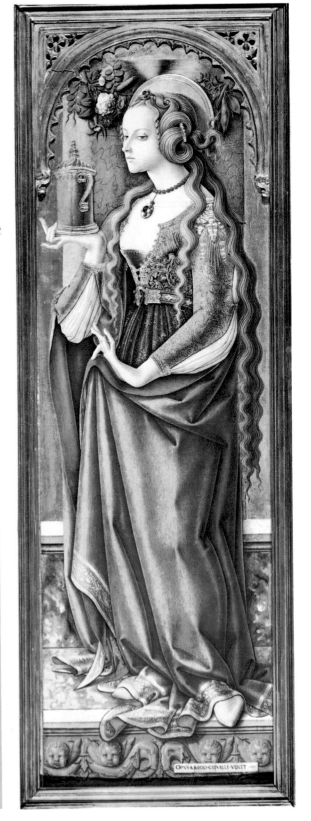

Crivelli: *St Mary Magdalene*
Francesco del Cossa: *St John the Baptist*
Tura: *Virgin and Child in Majesty*

The first phase of Renaissance painting was received in the Italian provinces through the adoption of harsh forms in an attempt to achieve the effect of sculpture. This can be seen in the unusually crisp treatment of the Mary Magdalene by Carlo Crivelli. Although born in Venice, his stylistic affinity to Mantegna suggests that he may have been trained in Padua, but Crivelli passed most of his later career in the Marches, and his work remained essentially provincial, tempered by the rich ornamental quality of Gothic art. The same could be said of the school of painters which flourished at the court of the d'Este family in Ferrara. Again Mantegna's work had a particular significance for artists like Cosimo Tura and Francesco del Cossa, but his forms and details were elaborated into a fantastic and decorative style peculiar to the area.

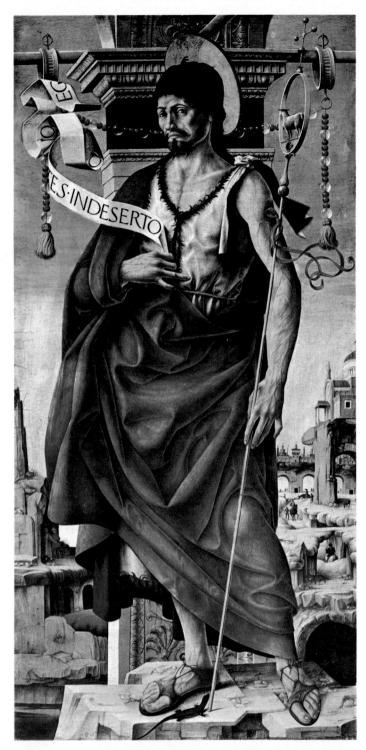

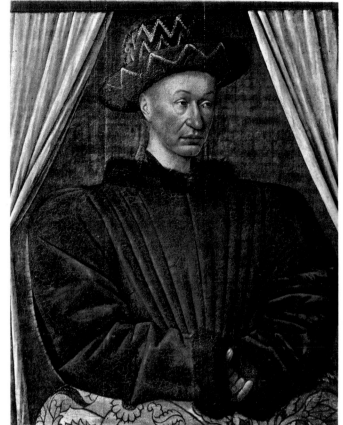

Jean Fouquet: *Portrait of Charles VII,* 86 × 72cm, c.1444

Isolated in the lagoon, and with no real interest on the mainland until the fifteenth century, Venice looked to the Eastern Mediterranean and the twilight of the Byzantine empire for the source of her wealth. For 300 years Venice had served as the major port for spices and exotic goods entering Europe, and the city was a kind of clearing house for their dispersal through the Alpine passes to the markets in the North. As a result, Venetian cultural life enjoyed an

Jean Fouquet: *Etienne Chevalier Presented by St Stephen,* 93 × 85cm, c.1450

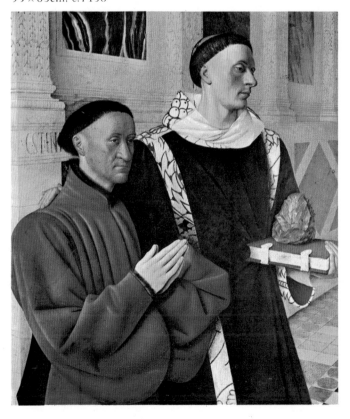

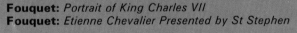

Fouquet: *Portrait of King Charles VII*
Fouquet: *Etienne Chevalier Presented by St Stephen*

The work of Jean Fouquet gives an indication of the impact that mature Renaissance art had on a painter from outside the mainstream of the new style. Fouquet was already an eminent painter in France as his portrait of the king bears witness, but his visit in 1447 to Italy where he met several leading artists and theorists completely transformed his style. Compared to the enclosed and somewhat frozen portrait of Charles VII, the panel of Etienne Chevalier presented by his patron saint demonstrates a confident awareness of form and space that is obviously derived from contemporary Italian pictures. This gave his work a significant authority in France, and on his return he became the leading artist patronized by the court and the most important public figure. Etienne Chevalier, who commissioned the diptych of which this panel was one leaf, was the King's treasurer and Fouquet's best patron.

OVERLEAF **Crivelli:** *St Mary Magdalene* (detail)

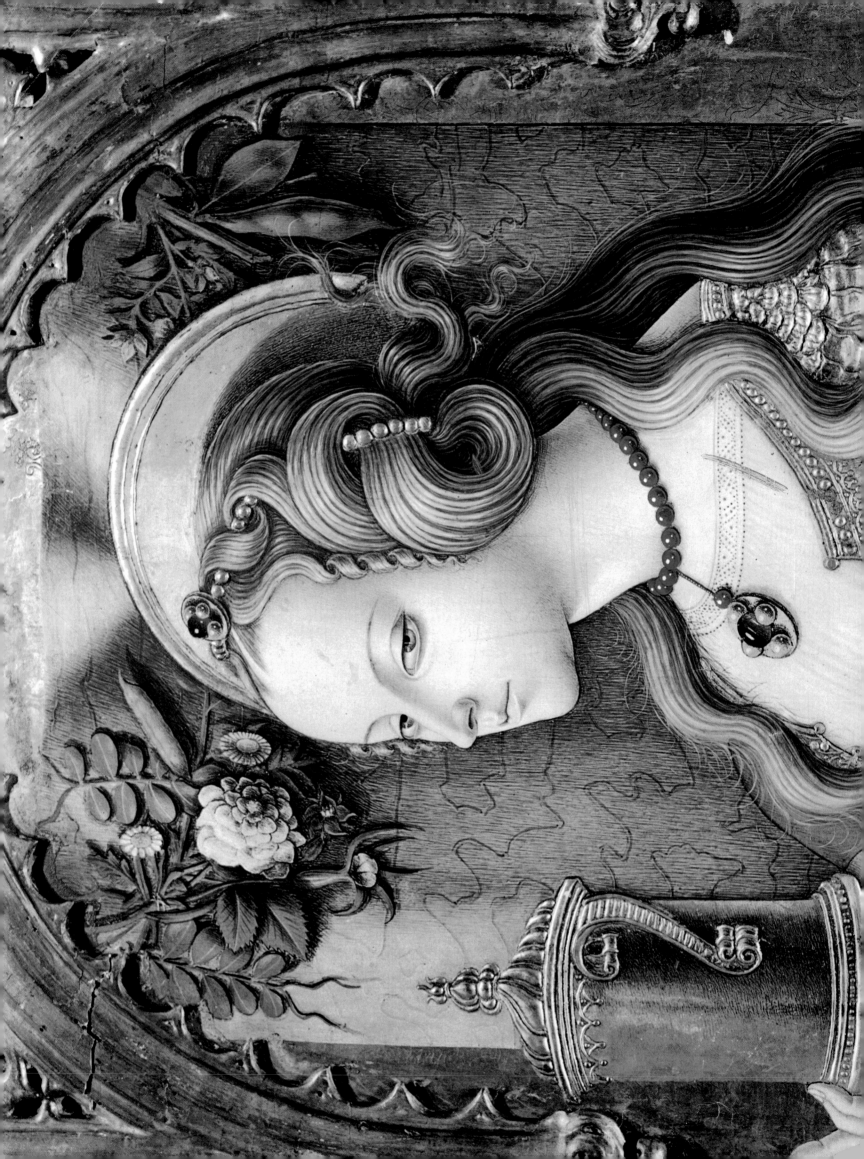

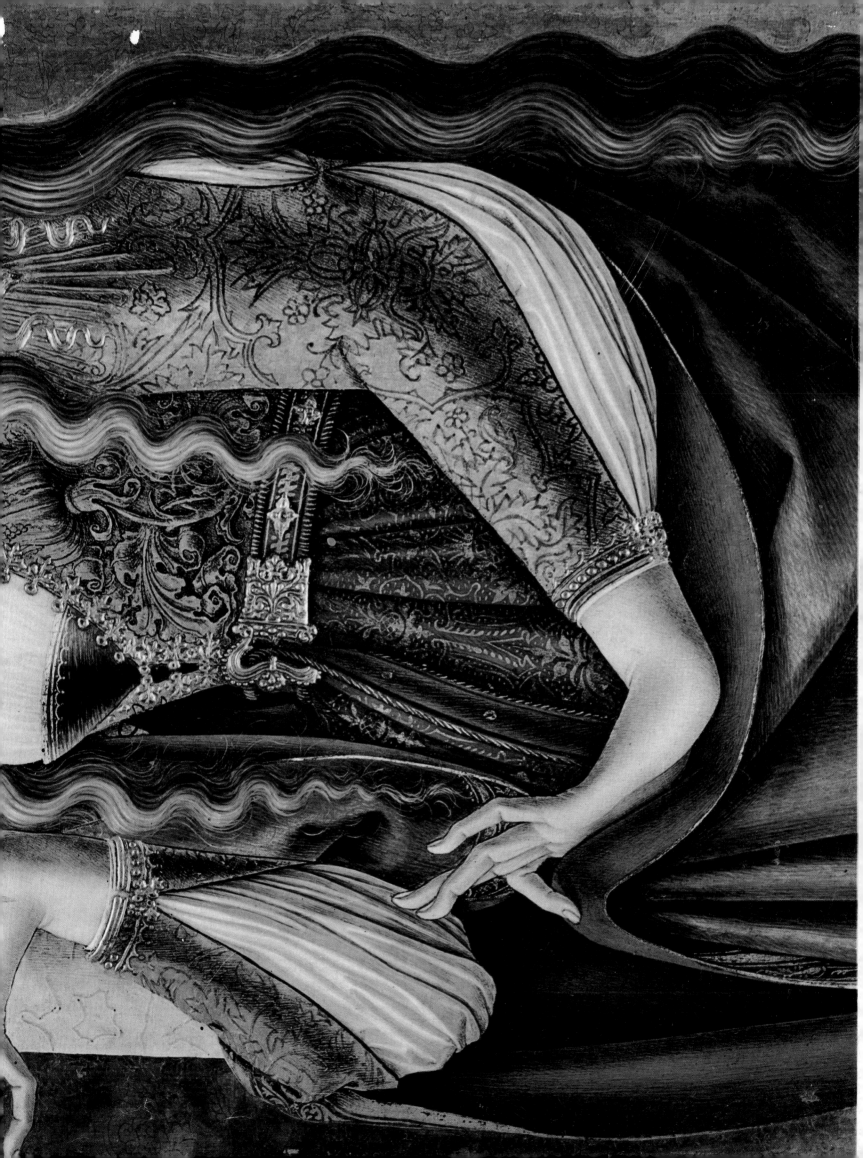

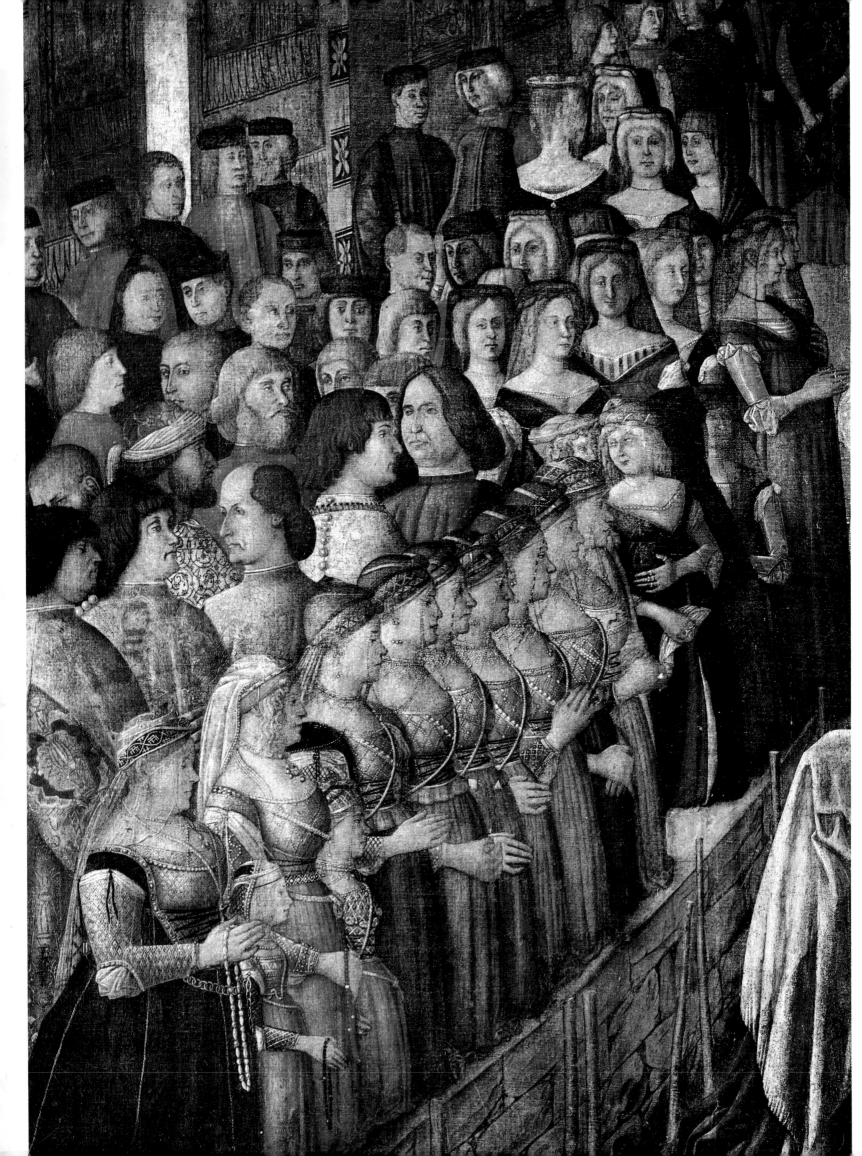

extremely cosmopolitan character, and its institutions were unlike those in other parts of Italy. Venice was governed by an enclosed clique, or oligarchy of a few families, from which the Doge, the head of state, was picked. However, real power lay with certain committees, like the Council of Ten, who carried out their activities in complete seclusion. The role of the Doge, therefore, had little more than a ceremonial func-

Gentile Bellini: *The Miracle of the Cross in the Canal of San Lorenzo*, 323 × 430cm, and details (opposite and page 48), c.1500

This picture was one of a series of canvases commissioned by the Scuola di San Giovanni Evangelista for their chambers in Venice. It depicts a famous event from the history of the fraternity: a fragment of the True Cross, which had been presented to them in the fourteenth century, was accidentally dropped from a bridge near San Lorenzo, but floated miraculously in mid-air until rescued by one of their members. As inhabitants of a holy city the Venetians put great store by the accumulation of holy relics, and these were regularly carried through the streets in procession. This scene has been represented with an eye for contemporary detail and it includes many important officials. The group of fashionable women on the left is headed by Caterina Cornaro, the former queen of Cyprus, who maintained a court for artists and writers in Asolo.

Lorenzo Veneziano:
*Polyptych of the
Annunciation* (detail).
1356–7

tion, to participate in the devout ritual and display that permeated all aspects of Venetian political life. Feast days, holidays, saints' birthdays and the like were all celebrated by the ostentatious processions that Gentile Bellini recorded in his paintings.

But the city's isolation from the rest of Italy could not be maintained against the increasing strength of the major states on the *terra ferma* and the consequent threat to the

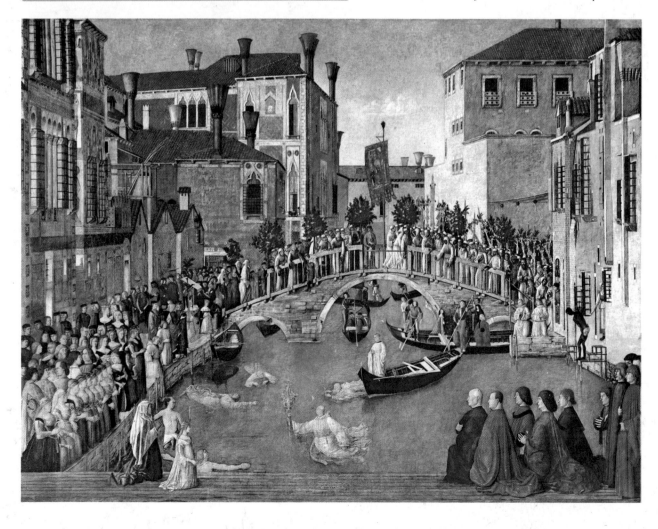

OPPOSITE **Gentile Bellini:** *The Miracle of the Cross in the Canal of San Lorenzo* (detail)

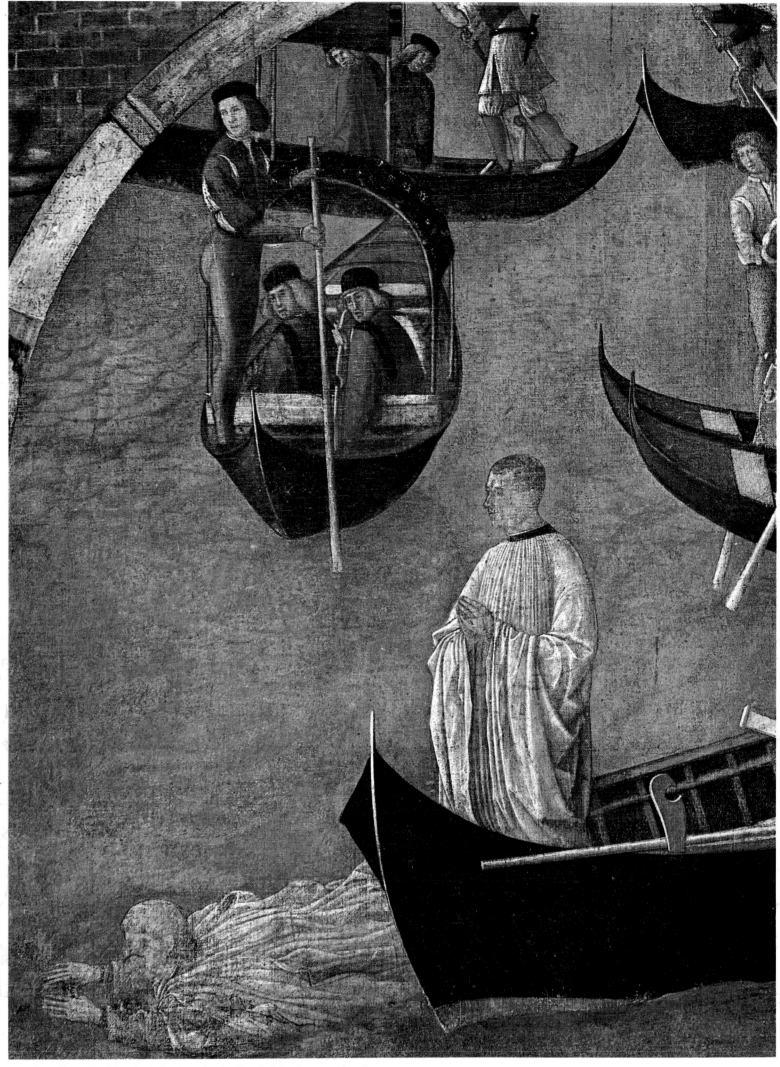

Gentile Bellini: *The Miracle of the Cross in the Canal of San Lorenzo* (detail)

trade routes. The Venetians were gradually drawn into the affairs of Italy, and the Quattrocento saw an expansion of their frontiers, from the Alps in the North to Ferrera in the South. Although this involved a series of wars with Milan and Rome, the new empire was a source of wealth, and it opened the city to a traffic in ideas and artists that transformed the nature of Venetian art.

The figure who dominates this period in Venetian painting, bringing it into the mainstream of Italian art, is Giovanni Bellini. He was one of the first artists in Northern Italy to appreciate the significance of the Florentine Renaissance, and, although he drew upon this tradition, it is a measure of his stature as an artist that he was able to remain independent.

The existing tradition in Venetian art reflected the commercial interests of the city, and, as such, was based on an amalgam of Byzantine and Northern European styles for which there was a secure market. In this climate, it is under-

Giovanni Bellini: *Pietà*, 107 × 86cm, c.1470

The *Pietà* is the culmination and the most perfect expression of Giovanni Bellini's early style. Here the sense of design and physical form that the artist had learned from the study of Mantegna and Donatello is enriched by a strong colouristic element. The figures are defined by a delicate modulation of colour in short hatched brushstrokes, which are carried into the land-scape and the morning sky to give the whole scene an effect of luminosity. Before encountering oil paints Giovanni had already developed the traditional tempera technique to its fullest possible extent. But in a picture such as this the technique is simply the means by which the artist works, and it is only in the ensemble that the depth of emotion is achieved. The colours, the setting, the figures, their gestures and expressions all communicate the profound sorrow and tragedy of the subject, and Giovanni has further emphasized it in the written couplet on the front of the sarcophagus:
When these swelling eyes evoke groans
This work of Giovanni Bellini could shed tears.

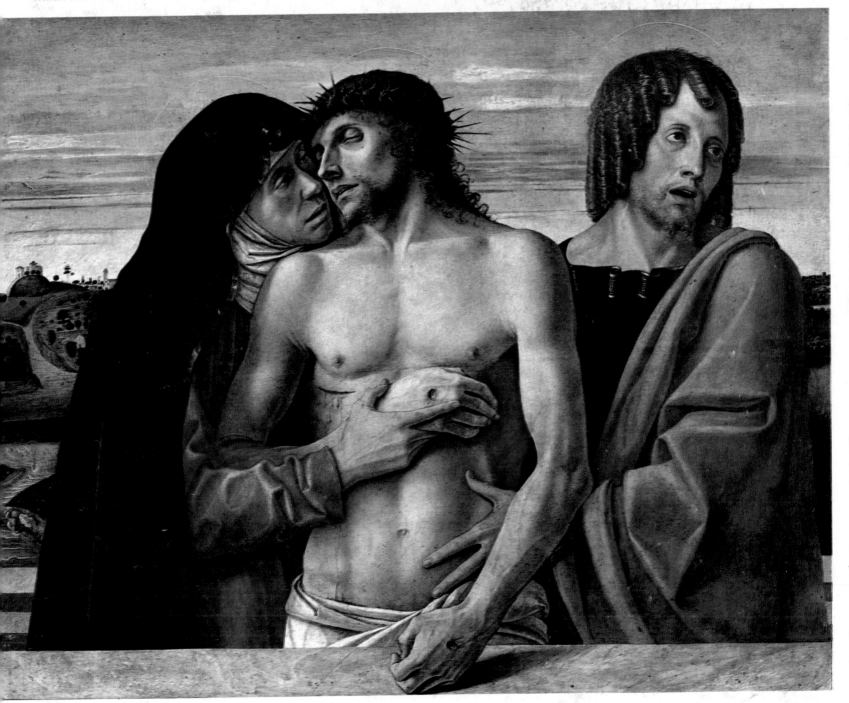

standable that the most important commission in the early fifteenth century, to decorate the Great Hall of the Ducal Palace, should go to Gentile da Fabriano and Pisanello, both of them representatives of the last phase of Gothic painting. Giovanni's father, Jacopo Bellini, was, in fact, a pupil of Gentile but whether he was dissatisfied with this style or not, Vasari describes how he successfully lured the young Mantegna away from the studio of his rival, Squarcione, by arranging 'to have Andrea married to his daughter'. Mantegna was, no doubt, content to be free of Squarcione's control, and his arrival in the Bellini studio marks the first stage in the formation of Giovanni's style. Although still fairly young, Mantegna was an extremely precocious artist who had already made quite a considerable reputation by his work in Padua. It is obvious that Giovanni Bellini was heavily influenced in style and technique by his brother-in-law. Even his earliest works in the 1450s demonstrate that sense of design and crisp delineation of form which Mantegna had communicated to other artists. Giovanni never lost the awareness of form and structure, but his work developed along a different path, exploring the possibilities of colour, light, and atmosphere which became the essence of later Venetian art.

The next stage in Giovanni's development was prompted by the arrival of Antonello da Messina in 1475, a painter of unusual experience and great distinction. Contrary to what Vasari says, it is unlikely that Antonello visited Flanders, but he was trained in Naples at the court of René d'Anjou, which at that time was a stronghold of French and Flemish art. In this environment he had come into contact with the most recent developments of Jan Van Eyck, and he fully appreciated the significance of this work in the context of Italian art. Throughout the early Renaissance there had been a growing awareness of Flemish painting, and the few examples that had filtered into Italy had been ardently collected and admired, but it was still regarded as something extraordinary. As a result, Antonello's arrival in Venice created a considerable stir and introduced a whole range of new forms, subjects, and manners which had no precedent in any Italian school.

The most engaging of these is the Flemish interest in genre or everyday life. Florentine painters, in their preoccupation with form and space, had little time for extraneous items that might divert attention from their primary aim. It is quite a contrast, therefore, to see Antonello's St Jerome in his study surrounded by a wealth of beautifully observed domestic details. A few years later Carpaccio gave a scene from the life of St Ursula a similar treatment, where the

LEFT **Carpaccio:** *The Dream of St Ursula,* 274 × 267cm, 1495

OPPOSITE **Antonello da Messina:** *St Jerome in his Study,* 46 × 36·5cm, c.1456

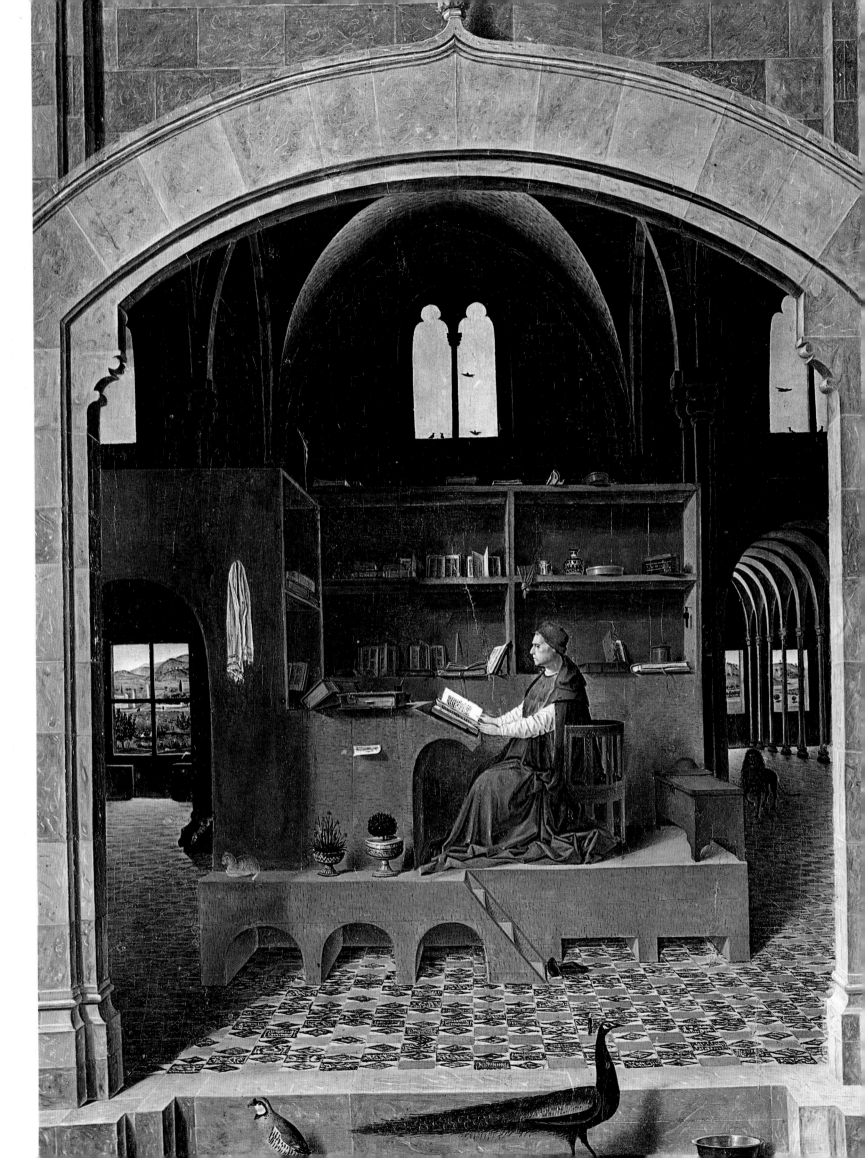

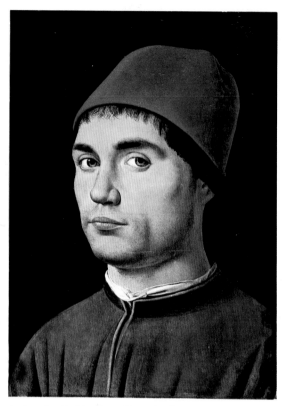

Antonello da Messina: *Portrait of a Man*,
35·5 × 25·5cm, c.1475

setting is so well rendered that the arrival of the angel in the sleeping Saint's bedroom has all the intimacy of a contemporary event.

Antonello was also a master of the realistic bust portrait in the Flemish manner, and this had a considerable following among the Venetians. The portrait itself can be seen as a uniquely Renaissance manifestation reflecting, as it does, the return to a system of thought in which mankind occupied the central place in the world. The earliest modern examples appear at the time of Giotto. This tendency was given plenty of encouragement in Florence since the donors wished to appear beside their patron saints in the altarpieces they had paid for. But among the humanists the individual portrait was reduced to a severe profile emulating the coins and medallions of antiquity. This left very little room for innovation, and the famous portrait of Federigo da Montefeltro, with its subtle light and landscape background, is about as far as the form could develop. Antonello's *Portrait of a Man*, therefore, was a model that permitted a much greater depth of characterization, as well as pictorial composition which Giovanni Bellini exploited to the full.

But, in the end, the most significant aspect of Flemish art which Antonello brought to Venice was the technique of painting in oil glazes. It was the greater flexibility of the oil medium over tempera which gave his pictures their exquisite finish. In this medium he could achieve subtle effects by using light to surround and define the figures, and it was these effects which appealed directly to Giovanni Bellini. Giovanni's own skill in manipulating oils suggests that he had already experimented with the technique but, on seeing Antonello's mature handling, his work entered a new phase in which the sense of volume in the picture is created by a delicate suffusion of light instead of by any structural frame-

work. This system is at work in the large altarpieces and the numerous madonnas produced by the studio, but it is seen to its best effect in the outdoor scenes of the 1470s and after. The fresh atmospheric quality evident in the early work is fully expressed in the background of the *Transfiguration* so that the landscape is no longer a mere backdrop but a complete setting that opens out the picture and communicates a powerful sense of 'naturalism'. The richness of this effect has led many people to describe the Venetians as great 'colourists' in the tradition of Byzantine art, but in Giovanni's hands the colour itself is only a vehicle for the light which bathes the scene and modulates the figures.

By the turn of the century Giovanni Bellini had become the master of the leading studio in Venice. Neither of his rivals, Gentile Bellini, his brother, or Antonio Vivarini, was able to compete with the quality and universalism of Giovanni's art, so the importance of their work declined into a purely provincial milieu. This is clearly seen in the later paintings of Gentile's leading pupil, Vittore Carpaccio. Although charming in their depiction of contemporary Venetian life, and even incorporating a good deal of Giovanni's feeling for light and air, by the sixteenth century they were obviously out of date. Carpaccio had failed to adapt to the new style and as a result he fell into relative obscurity. By contrast, Giovanni's work, even in old age, went from strength to strength, and the steady stream of pupils that passed through his studio ensured that landscape and a style of painting dominated by light, as opposed to line, would become the essence of Venetian art.

Antonello da Messina: *Portrait of a Man*. 30 × 24cm

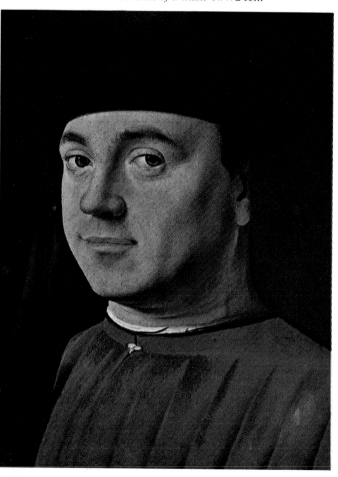

OPPOSITE **Giovanni Bellini:** *Portrait of Doge Leonardo Loredan*,
61·5 × 45cm, 1501

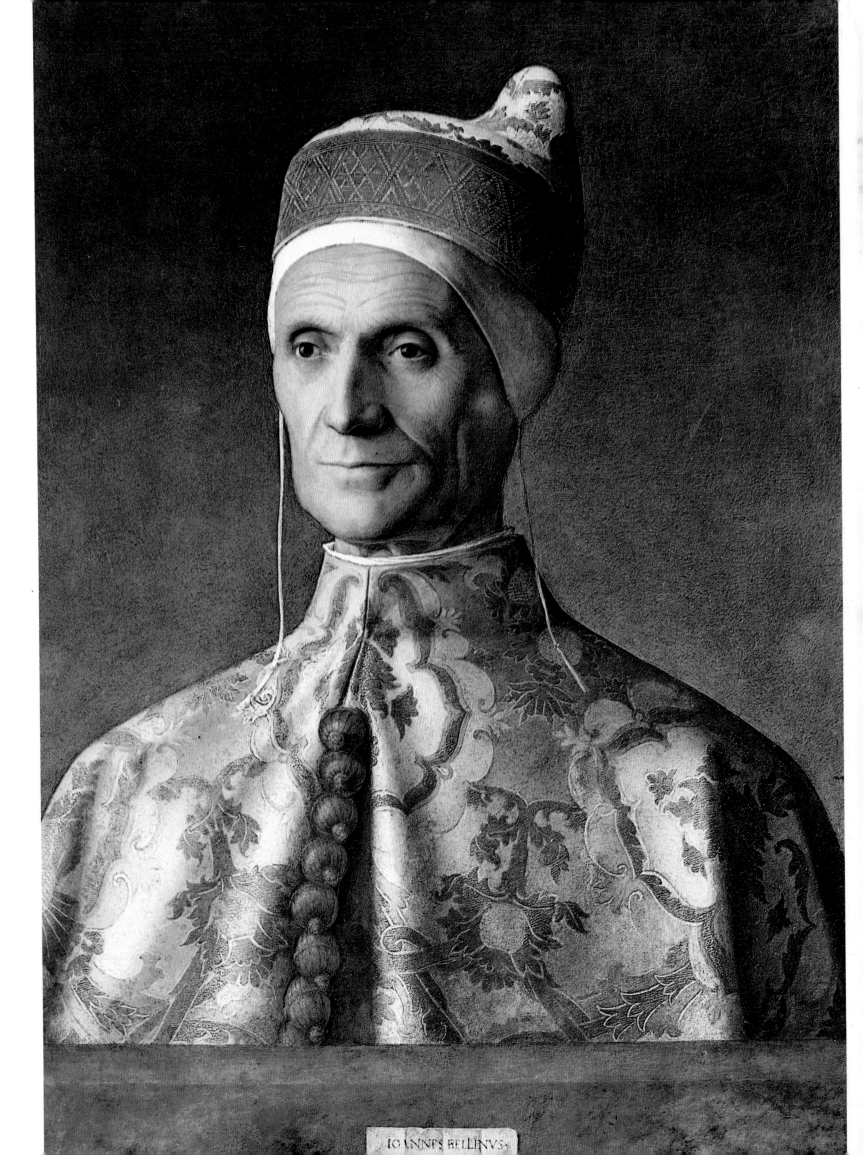

IOANNES BELLINVS·

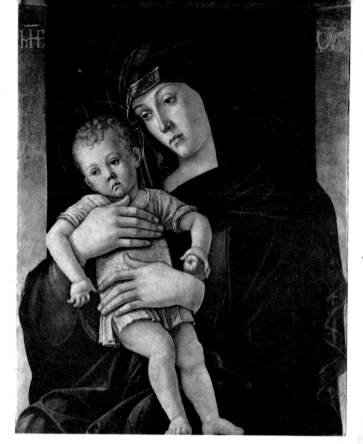

Left **Giovanni Bellini:** *The 'Greek' Madonna,* 62 × 82cm, c.1480
Right **Giovanni Bellini:** *Madonna of the Trees (Madonna degli Alberetti),* 74 × 58cm, 1487
Below **Giovanni Bellini:** *Virgin and Child in a Landscape,* 118 × 85cm, 1510

As in the Orthodox countries of the Eastern Mediterranean, most families in Venice had at least one picture of the Madonna in their homes, and there were some painters, called 'Madonnieri', who worked exclusively for this market. Giovanni Bellini was not specifically one of them although this type of picture represents a fair proportion of his work. His Madonnas were of the highest quality and throughout his career he brought a wealth of invention to the simple theme of the Virgin and Child. Apart from the sensitive description and handling of light, Giovanni's landscapes have a symbolic role and expand the iconographic interpretation of the scene. The two trees, for example, from which the *Madonna degli Alberetti* takes its name, are probably symbols of the Old and New Testaments. The unusual early *'Greek' Madonna* was probably painted for a Greek patron. This would explain the hieratic poses and inscription similar to an icon that give the picture its peculiar pathos.

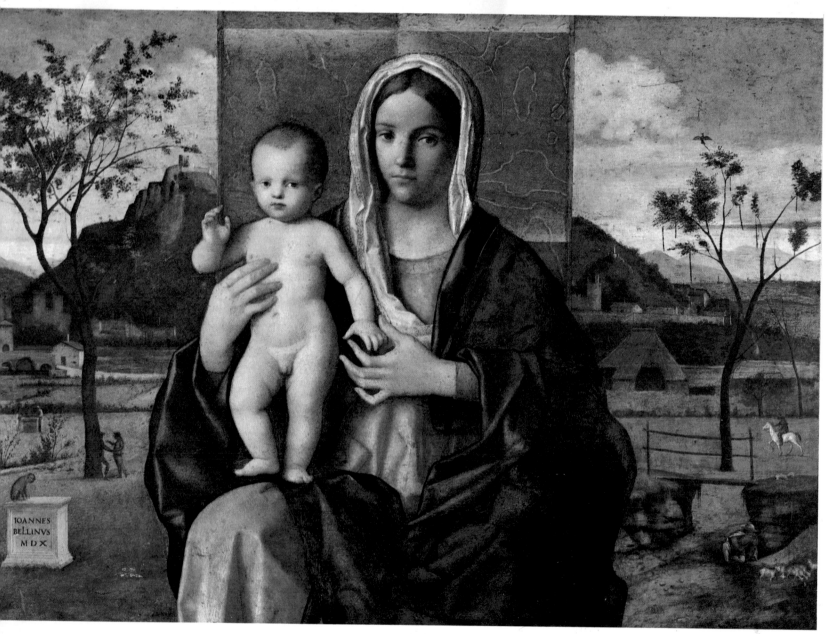

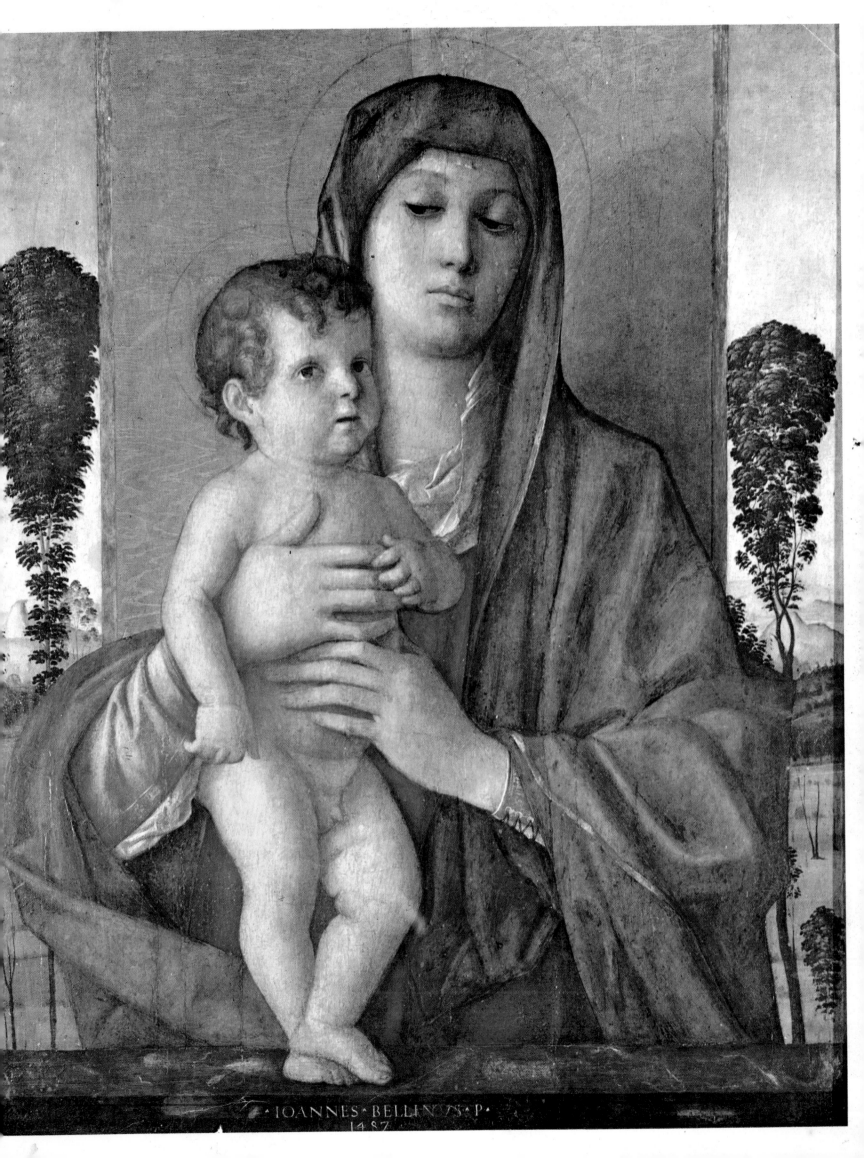

IOANNES · BELLIN°S · P·
1487

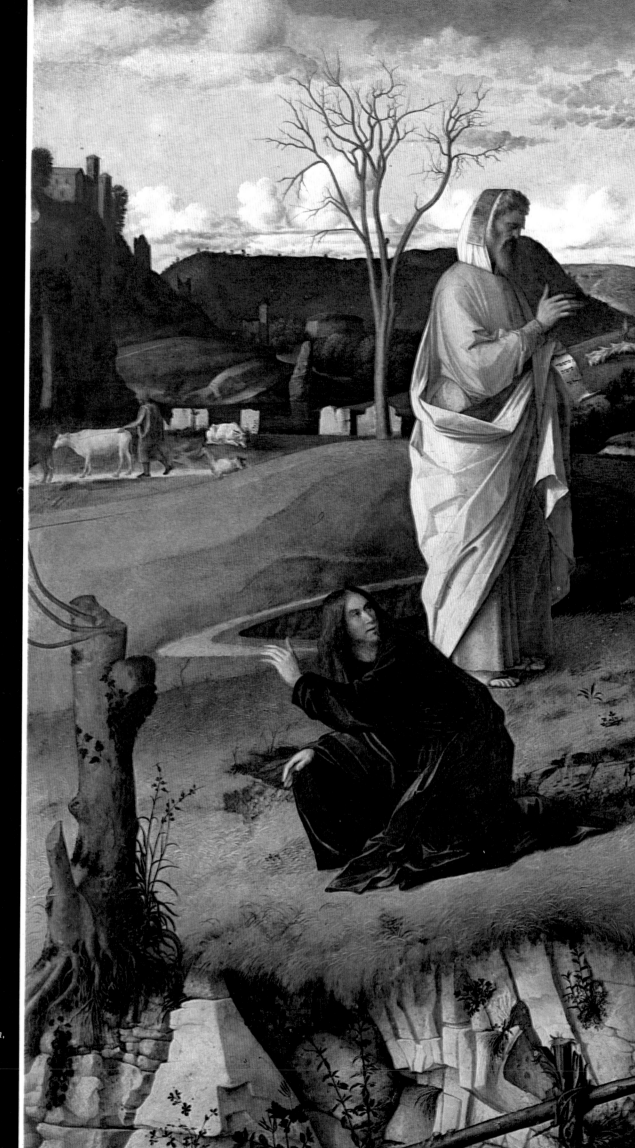

Giovanni Bellini:
The Trans- figuration,
115 × 151·5cm,
c.1485

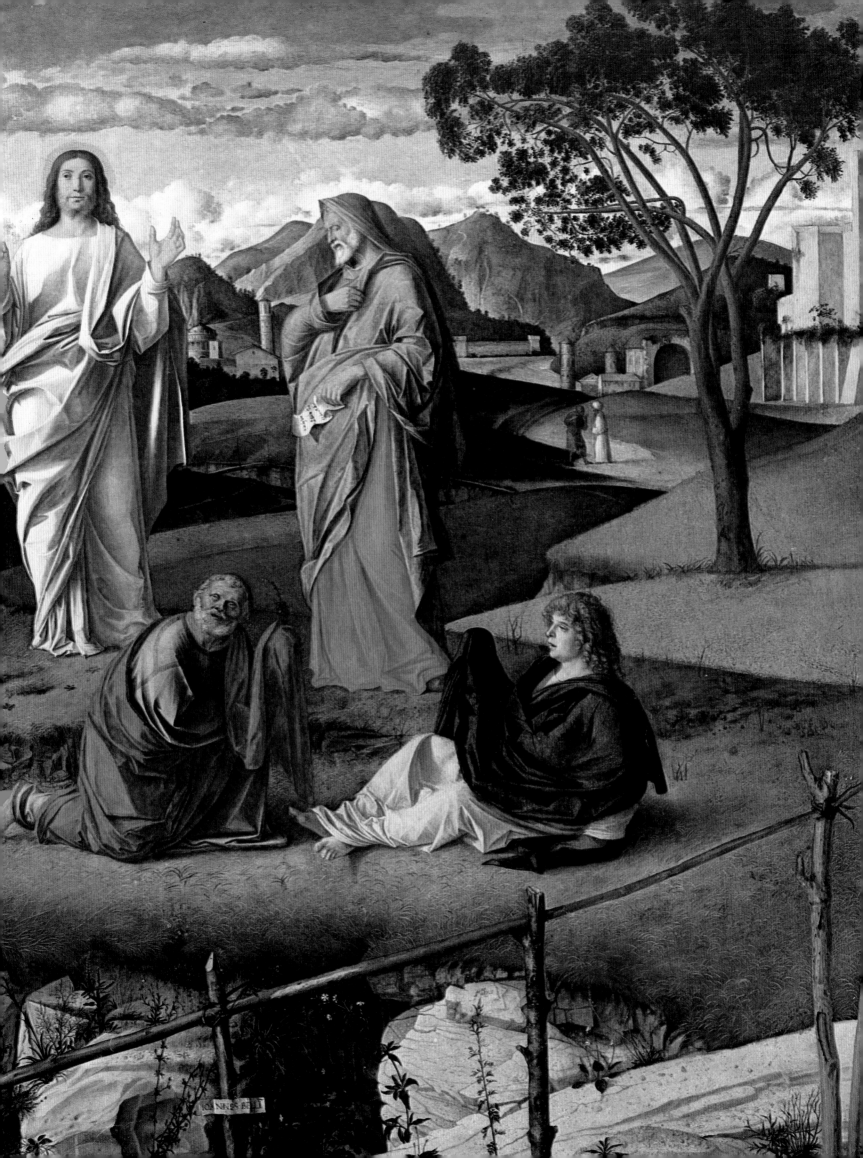

Since Vasari's reason for writing the *Lives* was to celebrate the artistic achievements of his own age, the third and final part was the most important. This, for him, was the 'summit of perfection', the climax of over 200 years of artistic endeavour, and we have endorsed his view by referring to it as the 'High Renaissance'. The term itself implies a level of accomplishment above that of the 'Early Renaissance', and it draws a distinction between the two. Whether or not there is any justification for this is a matter of dispute, but Vasari has defined it very clearly in his own terms, and, in focusing on the work of Leonardo da Vinci, he has pinpointed a transition between two separate approaches to painting.

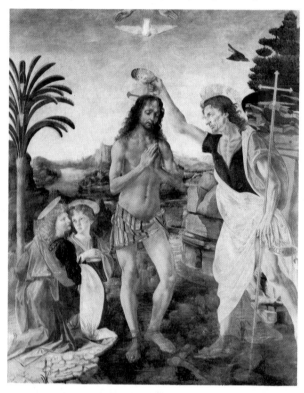

Leonardo da Vinci: *The Virgin of the Rocks*

The subject of this painting is based on the apocryphal legend that the Christ Child met John the Baptist in the wilderness, and it had already been treated by several artists, including Fra Filippo Lippi. But Leonardo's picture is infinitely more resonant and suggestive than any of the earlier interpretations. The barren rocky landscape and the atmospheric light falling across the figures to reveal their forms conspire to give this scene a visionary quality. Some time later Leonardo took the uncharacteristic step of painting a duplicate version, which is now in the National Gallery, London. This was probably painted to replace the original altarpiece, which had been removed from the church of San Francesco in Milan by Ludovico Sforza.

On one hand, Leonardo represents the culmination of the fifteenth-century Florentine tradition because he firmly believed that an understanding of the material world should be the primary interest of a serious man. This was the kind of understanding that Brunelleschi had sought to attain through the medium of perspective and Masaccio to represent in his paintings. But where they tried to reach conclusions and frame laws about the nature of their visual experience, Leonardo was content simply to observe. His belief was that knowledge or understanding could only be achieved through the process of experiment and observation. From this simple basis Leonardo felt able to approach any problem, and his drawings and sketchbooks demonstrate this in the way that he freely moved from studies of plants and animals to civil or military engineering projects, to architectural plans, to the movement of water and even to the natural forces of the deluge. With this range we are inclined to see Leonardo in a variety of roles, but it is not a matter of whether he was one thing or another; whether an artist, a scientist or an engineer; in the end, the distinction is irrelevant. To Leonardo any method which allowed him to explore the natural world was of equal interest. And a virtually coincidental result of this breadth in his experience and his urge to experiment was Leonardo's revolution within the practice of painting.

In the *Virgin of the Rocks* we are given a clear example of how Leonardo effected the transition between the hard Tuscan manner of the Quattrocento and the more 'graceful' style associated with the High Renaissance. In the first place,

Verrocchio: *The Baptism of Christ*, 117 × 151 cm, and detail, 1475

Leonardo da Vinci seems to have been a prodigious student, and Vasari describes in typically anecdotal fashion how Verrocchio gave up painting when he saw how well his pupil had painted the angel on the extreme left of the *Baptism*. Technical evidence supports the fact that this figure is by a different hand, and it already demonstrates the completely free and relaxed pose, as if caught between two movements, that Leonardo was to perfect in later years. The refinement of this pose, the imaginative treatment of the drapery, the delicate modelling of the head, and the calm spiritual expression of the features are unmistakably superior to the rest of the panel, and it could well be seen as the point of transition between the Early and the High Renaissance.

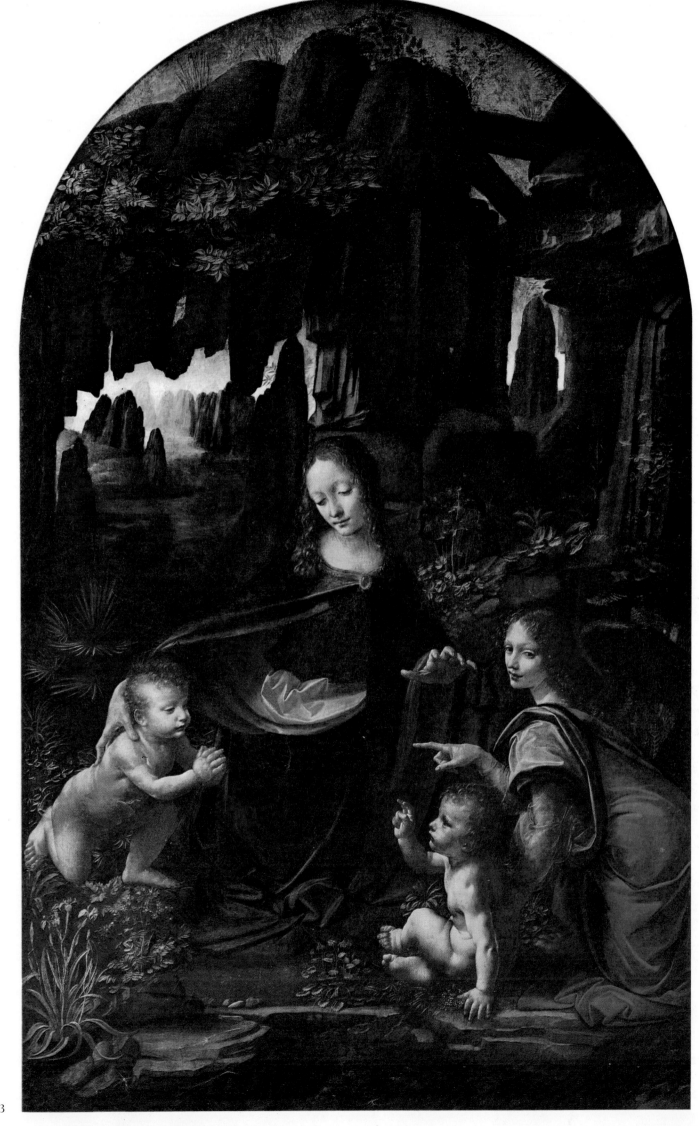

Leonardo da Vinci: *The Virgin of the Rocks,* 199 × 122cm, c.1483

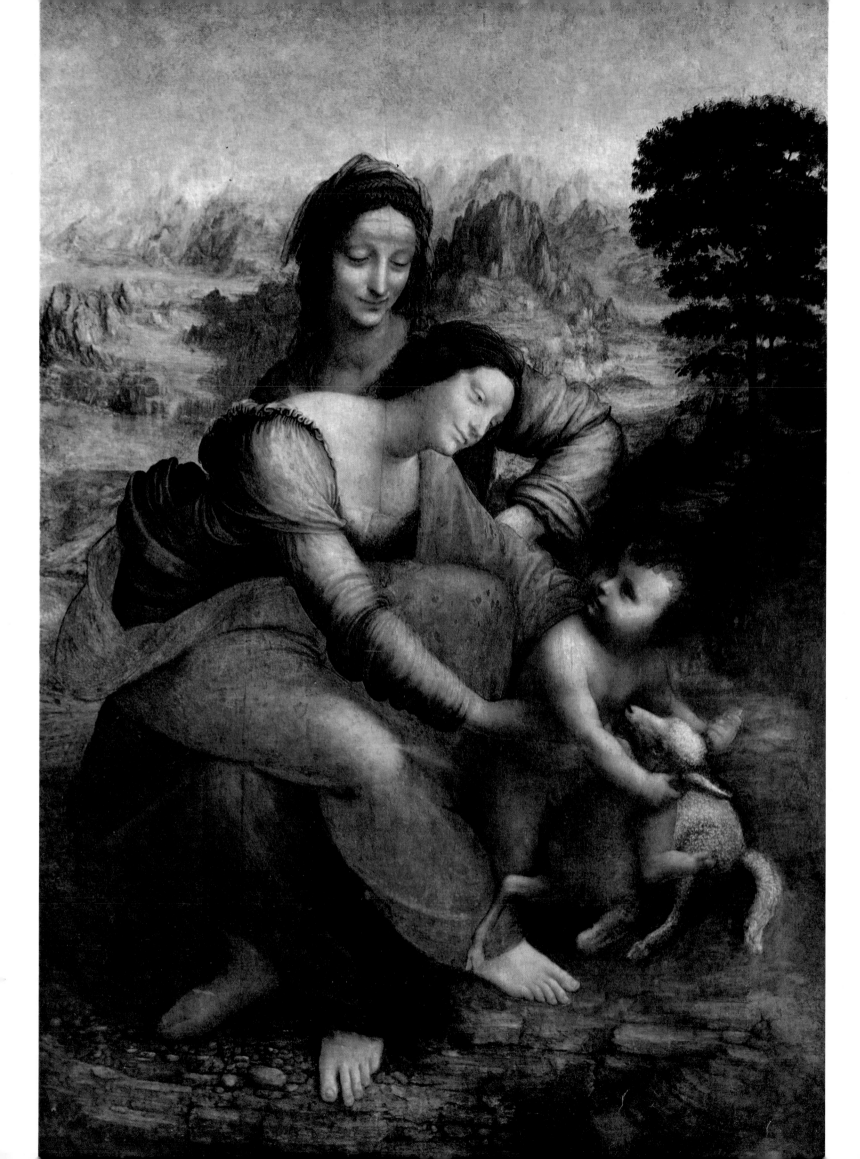

the composition of the group in the foreground has the classic structure of the pyramid, and the figures are organized with a deceptive ease that was beyond the repertoire of earlier Renaissance artists. But there is also an atmosphere in the barren landscape which gives the scene a completely new, visionary quality. This 'atmospheric' light which pervades the scene is a characteristic of Leonardo's work, and it can partly be explained in terms of technique alone because he made full use of the new oil medium. This should always be remembered when comparing Leonardo's work with that of his contemporaries, like Botticelli, because many of his effects of light and tone were impossible in tempera. But Leonardo evolved a new aesthetic around the medium based on his observations of natural phenomena. He was the first artist to fully exploit the way in which light and the passage of air affect the way we perceive objects, and he successfully rendered it in two ways. The first was an effect of aerial perspective where the tones blend towards a pale horizon giving the full impression of distance in the picture. The second was Leonardo's *sfumato*, a kind of modelling in light and shade which dispensed with colour. By making the figures appear through a fine veil of mist Leonardo could give the im-

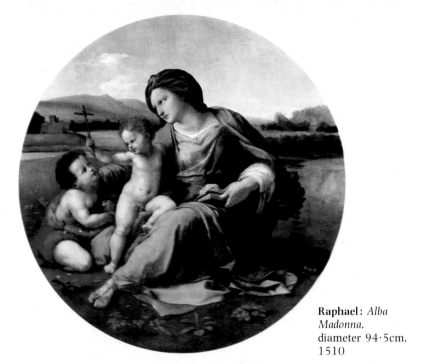

Raphael: *Alba Madonna*, diameter 94·5cm, 1510

pression of air surrounding the figures as he broke up the outlines which were so much a feature of earlier styles.

Much as these atmospheric effects were the result of Leonardo's optical experiments, they also contribute to a depth and subtlety of emotion, and even mystery, which is unprecedented in Italian art. The same can be said of the symbolism and iconography that Leonardo used even in the most traditional of forms. The Virgin and Child with St Anne was a popular subject for the small domestic altarpieces of the Quattrocento but it had not been given quite as complex an interpretation before Leonardo. Sacrificing the harmony of the composition, Leonardo created a dramatic tension in the picture by placing more importance on the relationship between the figures. The altarpiece had become the subject of complex theological interpretation instead of simple devotion. Nevertheless, it was a revolutionary design with an almost sculptural composition in depth. It exerted a powerful influence on the next generation, providing Raphael with the basis for a whole series of variations on the theme of the Holy Family.

From the numerous studies in his sketchbooks, Raphael seems to have worked in a similar method to Leonardo, an

Raphael: *La Belle Jardinière*, 122 × 80cm, 1507

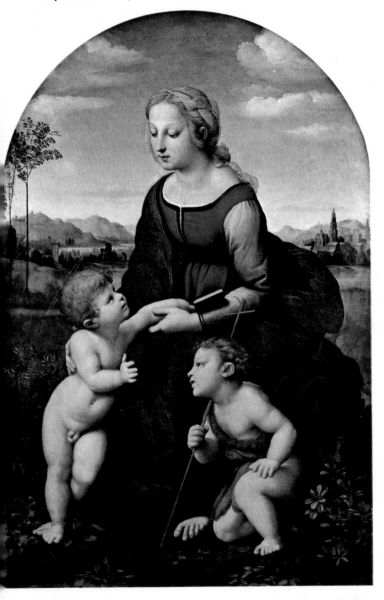

Raphael: *La Belle Jardinière*
Raphael: *The Alba Madonna*

Throughout his short career Raphael painted some forty or more small Madonnas in which he developed Leonardo's classic pyramidal composition. Two of his designs achieve their mature form in these pictures. *La Belle Jardinière*, so called because the Virgin is represented out of doors in a pastoral setting, was painted while the artist was in Florence. Here the simple design is a perfect vehicle to express both the religious and the human values in the relationship of the figures. The Madonna and Child are held together by glance and touch in a personal communication while St John gazes on in rapt adoration. *The Alba Madonna*, painted slightly later in Rome, places greater emphasis on the design, which is a truly supreme achievement. The complex problem of balancing the group within the tondo has been confidently overcome and the figures are easily disposed across the picture.

OPPOSITE **Leonardo da Vinci:** *The Virgin, Child and St Anne*, 168 × 130cm, c.1500

artist for whom he had an unqualified admiration. Beginning with a simple idea or shape, he would develop it in a series of drawings, posing problems in the structure or the relationship of the figures and then solving them, sometimes with a range of alternatives. The pictures which grew out of these studies demonstrate Raphael's mastery of composition and the ease with which he could articulate complex poses and figure groups within a simple classic structure. Even the tondo or circular picture, which was considered as something of a challenge to the artist's powers of design, only spurred him on to greater heights of achievement.

This feeling of ambition and self-confidence, which is one of the hallmarks of the High Renaissance, is partly the result of the new status artists enjoyed in the sixteenth century. The process by which the appreciation of art became an intellectual activity also distinguished the artist as more than a mere craftsman. Painting itself could now be considered as one of the liberal arts, and the people who practised it were received into the company of philosophers and poets. In a few instances, artists achieved positions of such authority and prestige as would have been inconceivable a hundred years earlier. No one epitomizes this more than Michelangelo, an artist who was held in almost mystical reverence by his contemporaries and sometimes referred to as 'il

Divino'. Vasari endorsed this totally, describing his hero as 'the man whose work transcends and eclipses that of every other artist', and the whole structure of the *Lives* was planned to reach a climax in the life of Michelangelo. It is in the very nature of Michelangelo's art to elicit this kind of response, but its full power and majesty was only possible in the spiritual and political climate of the early sixteenth century.

From 1494, the Italian peninsula was subjected to a series of invasions and wars of intervention by the armies of France, Spain and Germany. The effect of this was to shatter the uneasy political stability of the fifteenth century, and as the small states and principalities collapsed in the face of superior arms, the pattern of society which they supported began to wither. Machiavelli, a man whose name has become a byword for political scheming, was one of the few public figures with a true appreciation of the political realities of the times. He saw that the days of the small city states were over and, that if the affairs of Italy were to be free of foreign interference, a Prince was needed who would have the singularity of purpose to unify the country. No one rose to the occasion, least of all Cesare Borgia, the ostensible hero of *The Prince*, and in 1527 the army of Charles V devastated the country again in a campaign which culminated in the sack of Rome.

Perugino: *The Virgin, Child and Saints,* central panel 127 × 54cm, side panels 126·5 × 58cm, c.1507

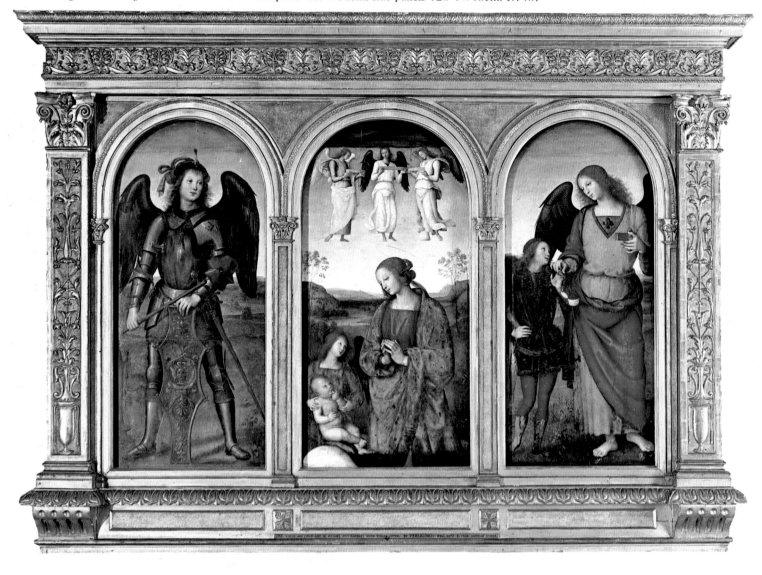

OPPOSITE **Raphael:** *The Marriage of the Virgin,* 118 × 170cm, 1504

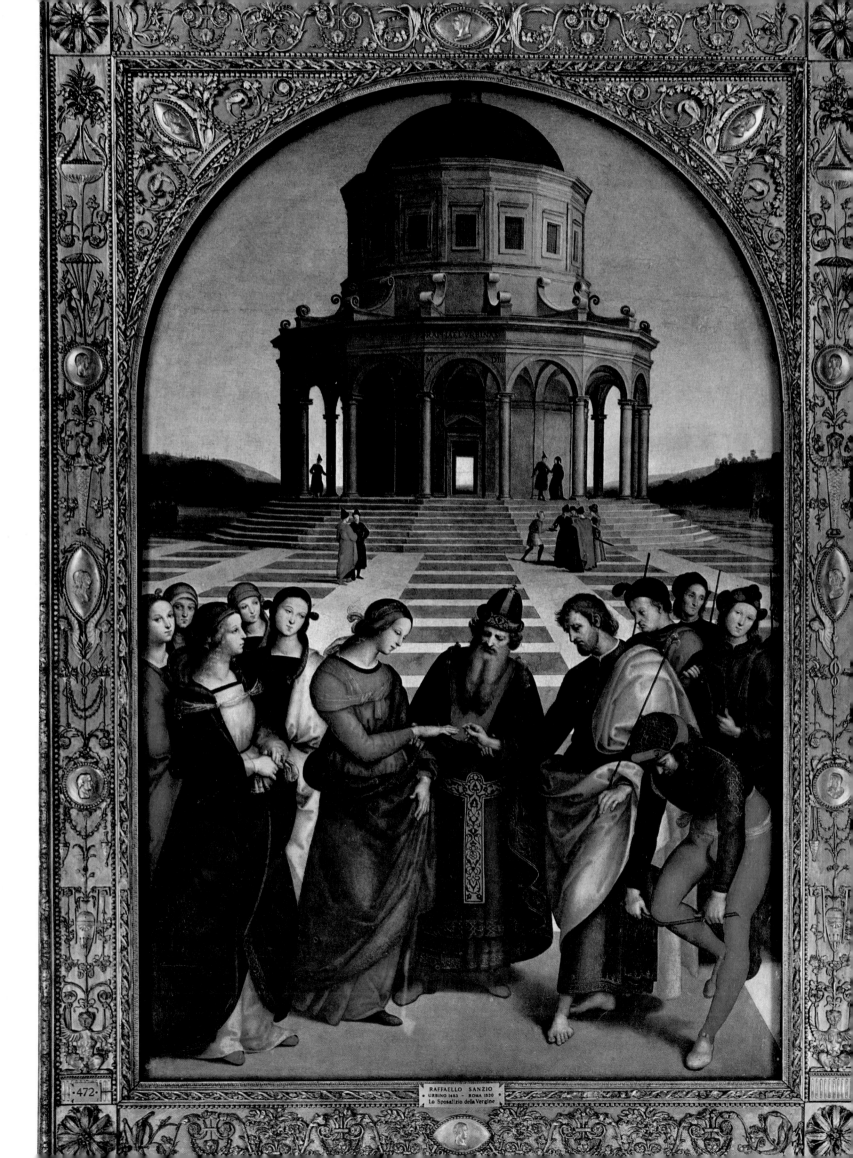

RAFFAELLO SANZIO
URBINO 1483 - ROMA 1520
Lo Sposalizio della Vergine

The two central figures framed by the arch are Plato with his dialogue, *Timaeus,* under his arm and Aristotle supporting a volume of his *Ethics.* Their positions and gestures represent the two supreme systems of classical thought; Plato pointing upwards to a realm of pure ideas while Aristotle on his left indicates the importance of the physical sciences in his philosophy. Among the other classical philosophers in the scene are Socrates to the left in profile counting off his argument on his fingers, Pythagoras at the bottom left with a boy holding a tablet of the theory of harmony, and Euclid demonstrating a mathematical problem at the bottom right. In a tribute to Michelangelo after seeing the first half of the Sistine ceiling, Raphael has portrayed him as the brooding philosopher Heraclitus beside the huge block of stone in the left foreground.

The one figure who could put up a reasonable opposition was the Pope, and, although his power did not prove to be enough in 1527, this period saw the papal states emerge as the richest and consequently the strongest in Italy. Throughout the fifteenth century the Papacy had been consolidating its position, and from the 1440s when Fa Angelico worked in Rome an increasing number of Florentine artists were attracted there with the promise of larger commissions and more money. Gradually the centre of artistic activity moved from Florence to Rome, and reached a climax in the papacy of Julius II, who outshone all his predecessors by the scale of his plans. He had whole areas of the city cleared for reconstruction, extended the Vatican apartments, commissioned

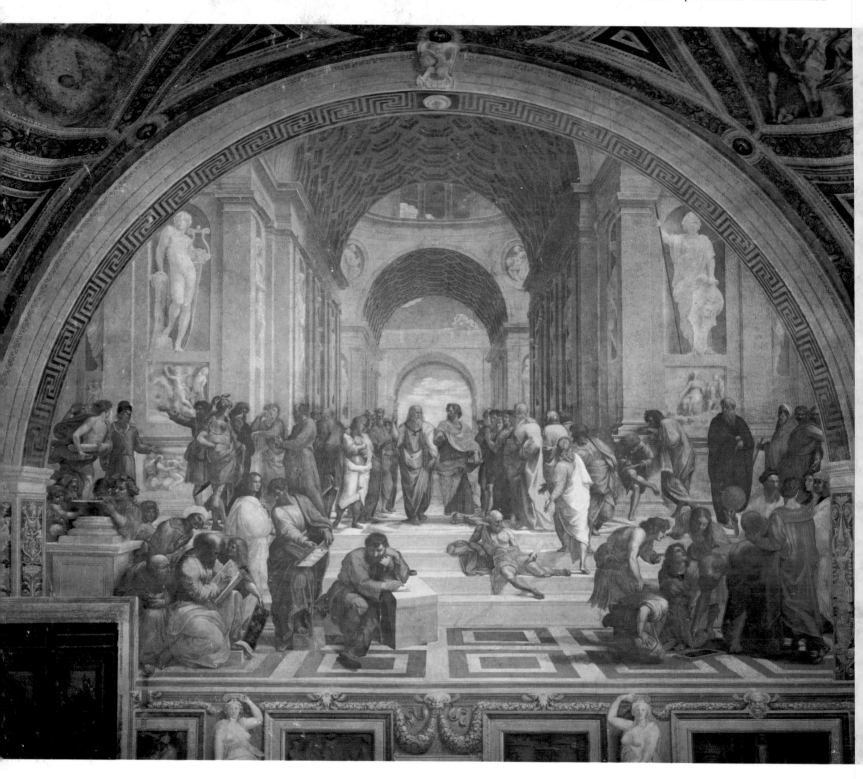

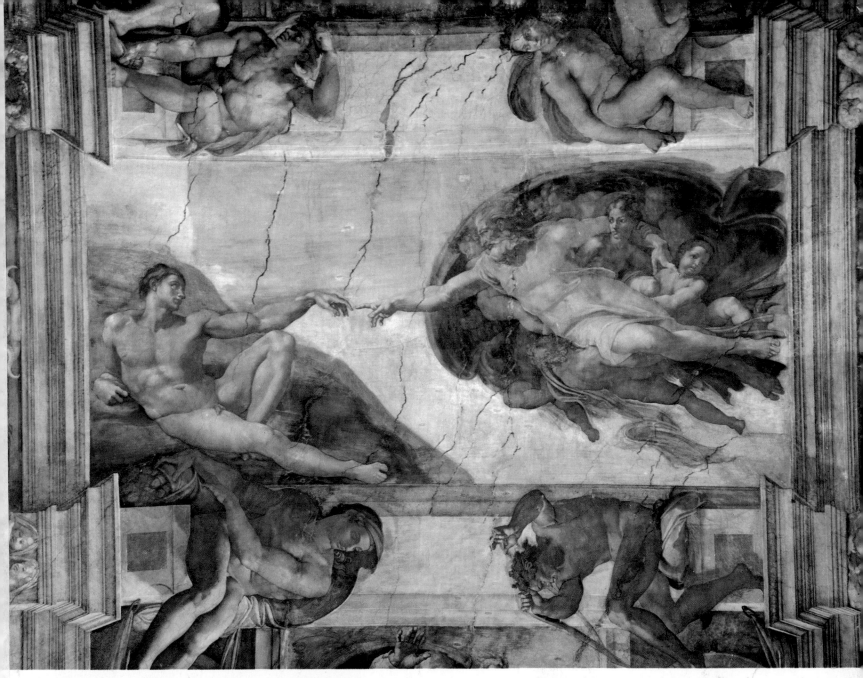

Michelangelo: *The Creation of Adam*, 1510–12

Michelangelo's *Creation of Adam* is one of the best known images in the history of art and, like the *Mona Lisa*, it has suffered from this fame to such an extent that it is now difficult to approach the work. Nevertheless, it was the intrinsic qualities of the picture which elevated it to such a position and one can still appreciate its power and originality. There are prototypes for the composition in the Quattrocento, but prior to Michelangelo the creation of Adam had been conceived in anthropomorphic terms. Uccello's version in Florence depicts a distinctly human God. Michelangelo's achievement therefore was to identify the figure of God in the creation, but to preserve the notion of a transcendent power behind the order of the cosmos. This was partly achieved in the animated group on the right, but the essence of the creation is contained in the gesture of the hands as the life force is about to be communicated to the listless figure of Adam, idealized in body and in mind as the archetypal substance of man before the deformation of experience.

large decorative schemes and, above all, adopted Bramante's colossal design for the rebuilding of St Peter's. This huge building dominates the period in the same way that Brunelleschi's architecture a century before had carried not simply the motifs, but the essence of the new art. In *The School of Athens*, one of the first subjects from the fresco cycle in the Vatican 'stanze', Raphael was directly inspired by Bramante's ideas to achieve a monumental architecture as a grandiose and heroic frame for his figures. Here, Plato, Aristotle and other great classical philosophers are represented with the symbols of their work, as a celebration of the rational search for truth reborn in the terms of the new age.

A similar sense of scale and magnificence is present in the other important fresco cycle in Rome at this time, the decoration of the ceiling in the Sistine Chapel. It was fitting that Julius should employ Michelangelo, already the most famous artist of his day, to undertake this commission, because the large chapel had been built by the patron's uncle, Pope Sixtus IV, and during the rebuilding of St Peter's, public services were conducted there. In other words, it was one of the principal churches in Rome. But Michelangelo's early biographers implied that the project was suggested by Bramante partly as a substitute for the sculptured tomb which Julius had shelved, but also as a means of discrediting Michelangelo in the eyes of the Pope. It was in many ways

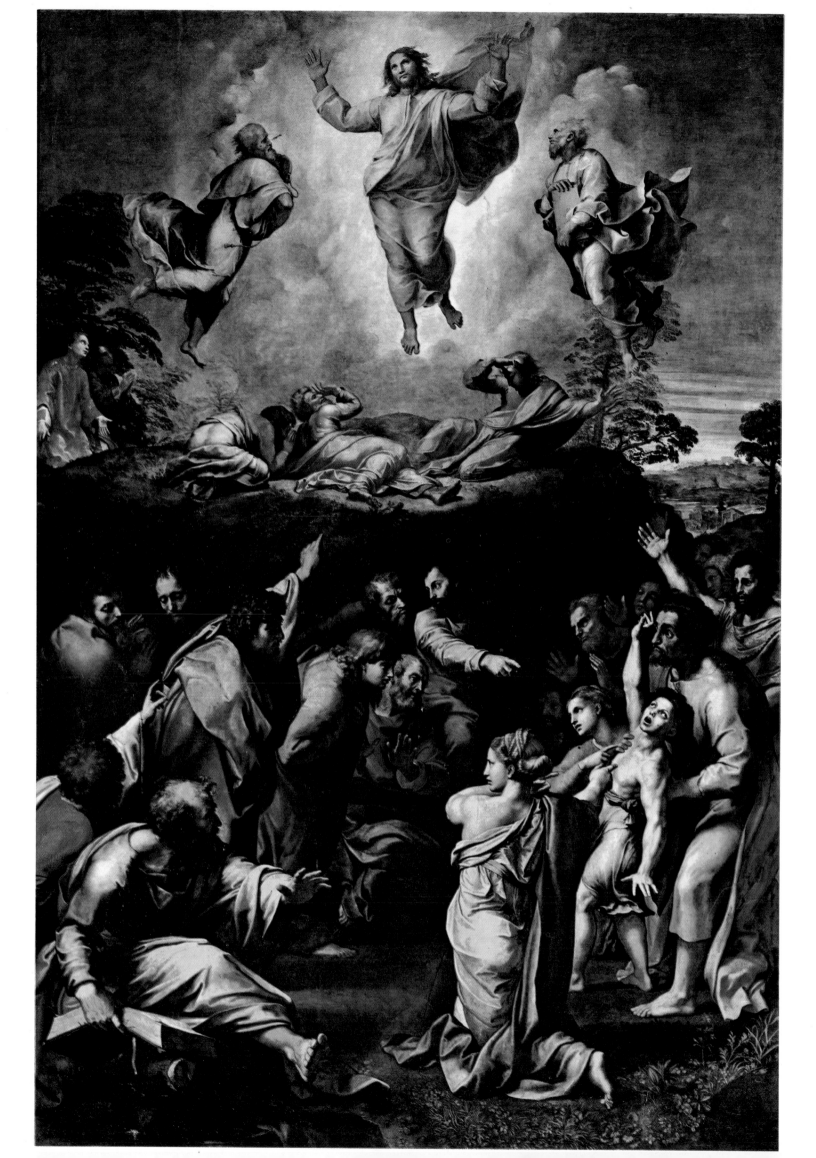

In 1510, when the first half of the ceiling was completed, the scaffolding was taken down and Michelangelo had the opportunity to study the effect of his work from the ground. This cannot have been as powerful as he intended because in the second half the figures are much larger, more dramatic and with greater animation in their poses. The difference between the two sides corresponds to two stages in Michelangelo's own development, and it is in the second that we see the full significance of the High Renaissance. The heroic grandeur of the later prophets and sibyls indicates a completely new breed and demonstrates Michelangelo's ability to combine monumental figures in dynamic poses, while still retaining that quality of effortless 'grace'.

The balance that was achieved between action and repose, between monumental form and complex ideas, a characteristic of the two great fresco cycles of the High Renaissance, was not maintained for any length of time. Already within the athletes of the Sistine ceiling there is a tendency to refine gestures and poses which made them easily accessible as stock characters, to be diluted in the work of imitators. In Raphael's later Stanze there is a move away from the classic order of his composition in *The School of Athens*, to a style which involved greater movement and drama. Raphael died before this tendency could fully develop, but his last picture, *The Transfiguration*, amply demonstrates that the classic style of the High Renaissance had run its course, leaving the field open to a new generation of artists to forge their own artistic styles and mannerisms in response.

Vasari's definition of the High Renaissance, framed as it was in the terms of Florentine painting, cannot be as easily applied to Venice. In the first place, Giovanni Bellini's career

Bronzino: *Allegory of Love and Time.* 146 × 116cm. 1545–6

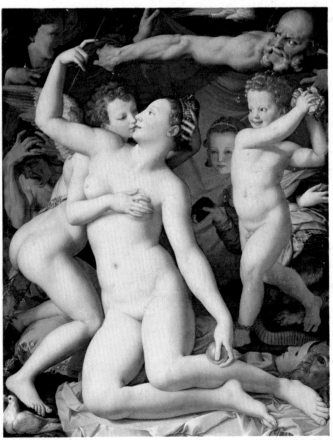

Opposite **Raphael**: *The Transfiguration*, 410 × 279cm, 1517–20

Raphael's *Transfiguration* was commissioned by Cardinal Giulio de' Medici in competition with a painting, *The Raising of Lazarus*, by Michelangelo's protégé, Sebastiano del Piombo. This explains something of the circumstances of the commission, and its importance was such that Raphael did not entrust it to his assistants as was his normal practice at this time. Instead, he personally devoted a great deal of time and thought to the subject. The iconography and the design are both very sophisticated since the picture brings together two separate events from the Gospels: the Transfiguration itself when Christ's divinity was revealed in a dazzling light and the prophets Moses and Elijah appeared on either side to converse with him, and the attempt by the disciples to heal a boy possessed by devils. The contrast between the unrestrained drama of the earthly group and the divine radiance of Christ is completely successful, but it marks a significant departure from Raphael's earlier, more 'classical' style. In April of 1520 Raphael died, leaving the picture to be completed by Giulio Romano and Francesco Penni, and this has raised questions about how much of the expressive emotion can be attributed to the master.

an unsuitable commission, since Michelangelo considered himself as primarily a sculptor, but he had practised painting in the studio of his early master Ghirlandaio, and there are examples of his work from this period. This story, although not a complete fabrication, was probably circulated to show how Michelangelo could triumph in the face of opposition from his rivals, simply by virtue of his innate ability and the force of his character. The original commission, in fact, had been for only twelve figures in the lunettes above the windows, but in a letter, written some years later, Michelangelo mentions how he complained to the Pope that it was a rather impoverished scheme and that Julius gave him a new commission to do what he wanted. Michelangelo had established his right to individual artistic freedom. The scheme which he designed himself is partly an extension of the earlier tomb project, and a brilliant solution to the problem of how to approach the unusual shape of the ceiling. It is a shallow barrel vault with windows cut into both sides. Characteristically, Michelangelo turned the difficulties of the location to his advantage by employing the structure of the ceiling itself to strengthen and invigorate the composition. Within an illusionistic architectural framework, Michelangelo has disposed over 300 figures in a vast intellectual programme centering on the Creation of Man. The core of the scheme is nine episodes, or 'Histories', from the book of Genesis along the centre of the ceiling, but these are surrounded by athletes and the prophets and sibyls of the ancient order relevant to a particular interpretation of the story. The narrative section is further bound up with a larger philosophy. By compelling the spectator to read the 'Histories' in reverse order, beginning with the *Drunkenness of Noah* and ending over the altar with the *Separation of Light from Darkness*, Michelangelo has given visual expression to the Neo-Platonic doctrine, popular in the Renaissance, that life must be a progression from the slavery of the body to the liberation of the soul in God.

spans the period of transition between the early and the High Renaissance and even in the early years of the sixteenth century his position as the leading figure in Venetian art was unchanged. In 1506 the German artist Albrecht Dürer remarked. 'Though he is old he is still the best in painting', and, even at this stage, Giovanni still had ten productive years before him. So instead of the abrupt changes in style which were noted in Florentine art, a continuity of tradition passed from the aged Giovanni Bellini to his younger pupils, and this formed the basis for the Venetian school in the sixteenth century. The problems which this posed for Vasari when he came to write on the Venetian artists can be seen in his rather insubstantial life of Giorgione, and it gives the impression that he was not particularly interested in the subject. Nevertheless, he has attempted to give Giorgione a distinct historical position by placing his biography next to Leonardo's, and this illuminates the way the two artists were concerned with similar problems.

Leonardo in fact visited Venice for a few weeks in 1500, and although there are no works which he is known to have left there, many people have been inclined to see traces of his style in Venetian paintings of the following decade. This may be the case in the small picture known as *The Tempest* which is generally attributed to Giorgione. As a simple

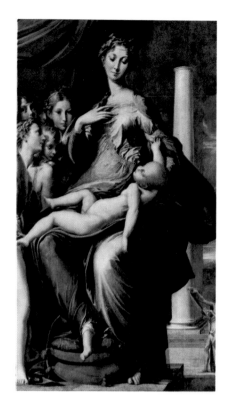

Parmigianino:
Madonna of the Long Neck. 216 × 132cm. 1535

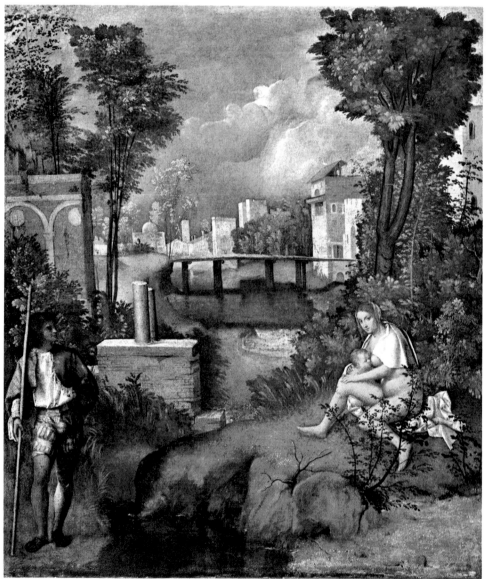

Giorgione: *The Tempest.* 82 × 73cm. c.1506

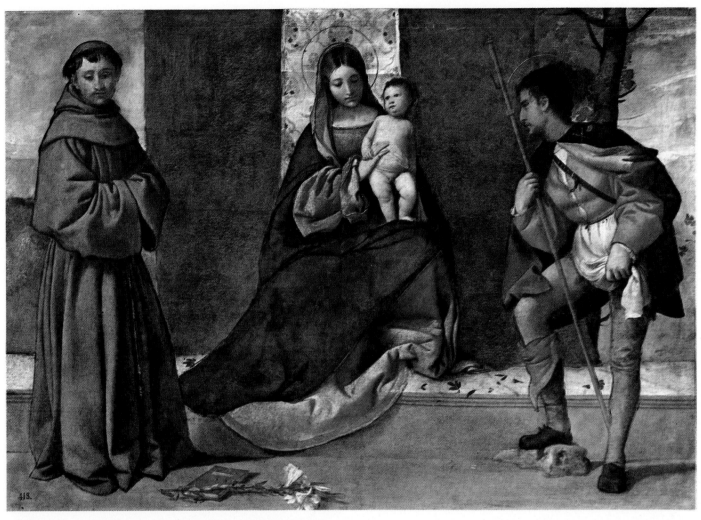

Giorgione: *Madonna and Child with the Saints Anthony and Roch*, 92 × 133cm, c.1508

This altarpiece is one of a group of pictures that, in the absence of contemporary documents, have been alternately attributed to Giorgione and Titian. The grand, flowing composition is close to Titian's youthful work, but the mode of painting, which is probably original since parts of the picture remain unfinished, runs completely against this view: the conception of the figures, the oval form of the Virgin's head and the delicate suffusion of light surrounding and articulating the forms all accord with what is known of Giorgione's style. The altarpiece itself is of the type known as a 'Sacra Conversazione', which was particularly popular in northern Italy. The sacred figures are gathered together in a single space with some particular significance, for either the donor or the church for which it was intended. In this case the inclusion of Saint Roch, the Saint most often invoked against epidemic, implies that the commission was related to one of the frequent outbreaks of plague in Venice.

light. The picture has been conceived in a harmony of colours which are repeated and echoed throughout the composition so that figures and landscape are inseparable. The same is true of the atmosphere in the painting because Giorgione's unified vision has imposed a mood on the landscape which corresponds to the feelings of the inhabitants. As such, this is a completely new kind of picture. The landscape with figures is no longer an observed scene or even directly symbolic, and this is emphasized by the numerous

Overleaf **Giorgione:** *Venus*, 108 × 175cm, c.1510

When the Venetian writer, Marcantonio Michiel, saw this picture in 1525 he reported that 'the nude Venus asleep in a landscape, with a cupid, was by the hand of Giorgio da Castelfranco; but the landscape and cupid were finished by Titian.' This report is probably accurate because there was once a cupid at the feet of Venus, which has since been painted out, and the landscape was repeated by Titian in his *Noli me Tangere*. Moreover, it is not unreasonable to assume that the unfinished works left in the studio after Giorgione's death would be completed by his young associate. The picture was certainly very important for Titian, and he constantly reworked the classic figure in a series of reclining nudes, the *Venus of Urbino* being the finest version.

landscape it is well realized with a quite profound lyrical beauty, but this has tended to conceal the subtlety with which the painter has merged the two figures into their setting. Very few artists of the Quattrocento attempted this, and even Leonardo's *sfumato* can appear somewhat schematic alongside Giorgione's manipulation of colour and

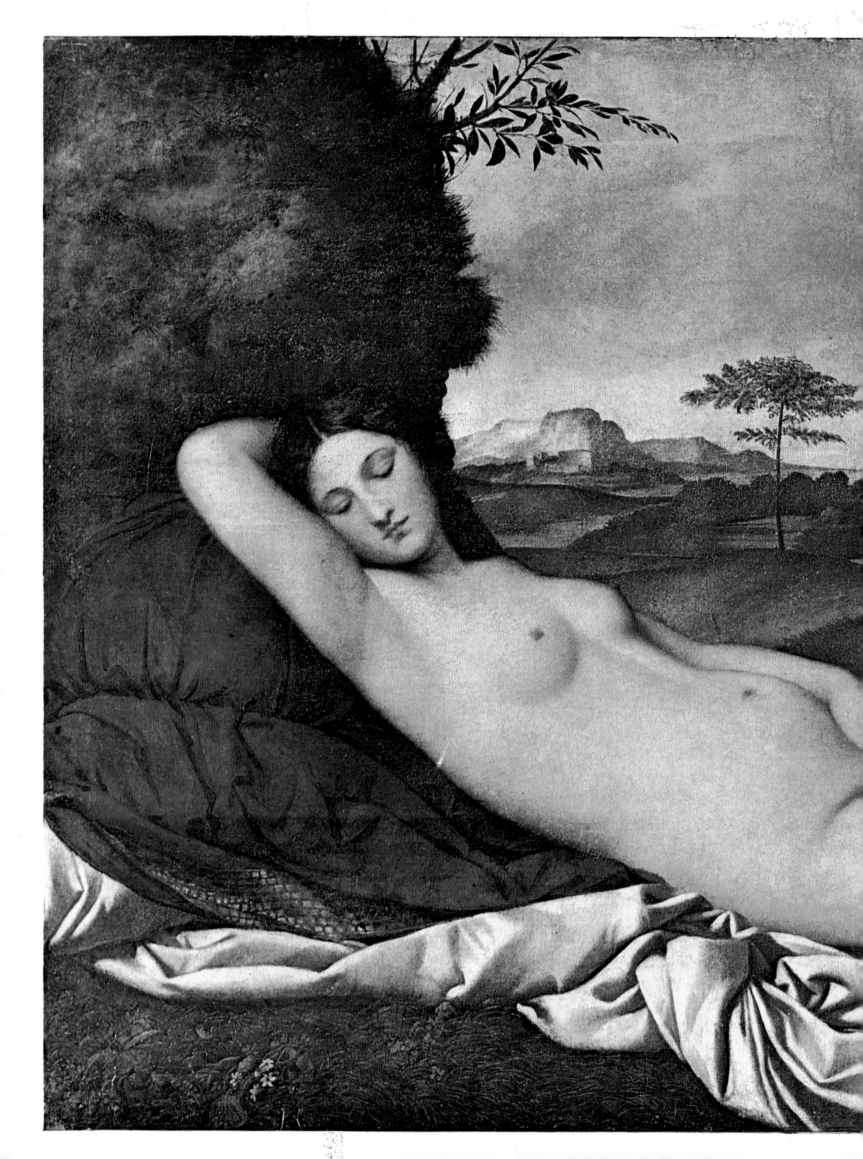

49

improbable elements in the painting. The calm foreground is unaffected by the storm breaking in the distance; the buildings and antique remains have no structural or spatial logic, and, most potent of all, the juxtaposed figures of a soldier and a woman suckling her child would seem to have some meaning which their apparent informality does nothing to elucidate. In fact, if there ever was a specific meaning it had been lost within a few years: a possible conclusion is that from the very beginning the picture was intended as an enigma, or a fantasy, with no relevance to the affairs of the everyday world. A picture of this type was referred to as a *poesia* because it was designed to induce the kind of response more commonly associated with poetry, and it appealed directly to the new humanist patrons in Venice. They would perhaps have appreciated more of the subtleties because it was probably commissioned by one person for his private room, or *studiolo*, where he could reflect upon it surrounded by the books and objets d'art of his preference.

Giorgione's monumental *Venus* may well have been created for the same market, but this picture raises problems of a different kind which lie at the very heart of any dis-

cussion of the period. According to a contemporary commentator, the arcadian landscape in which the sleeping goddess lies was painted by Titian, an assistant or close follower of Giorgione who had also passed through Giovanni's Bellini's studio. This statement is universally accepted, but, since the practice of repainting another artist's work was not uncommon, it is difficult to separate the hand, and, therefore the artistic personality, of one painter from the other. As a result, there is a body of superb works from the early sixteenth century which have been variously attributed to either, or both Giorgione and Titian, with no justification beyond personal opinion. If a distinction can be made, it must rely on Titian's later work which shows a greater concern for colour as opposed to the evocative atmospheric effects of Giorgione. The vivid *Sacred and Profane Love* of 1516 is obviously related to Giorgione's fancy pictures, but the various elements are clearly defined and it is a more direct representation of the allegory. Unlike *The Tempest*, figures and setting obviously have a meaning that can be interpreted. In the form and structure of this work, Titian comes closest to the 'classical style' of the sixteenth century

Titian: *Venus of Urbino*, 119 × 165cm, 1534

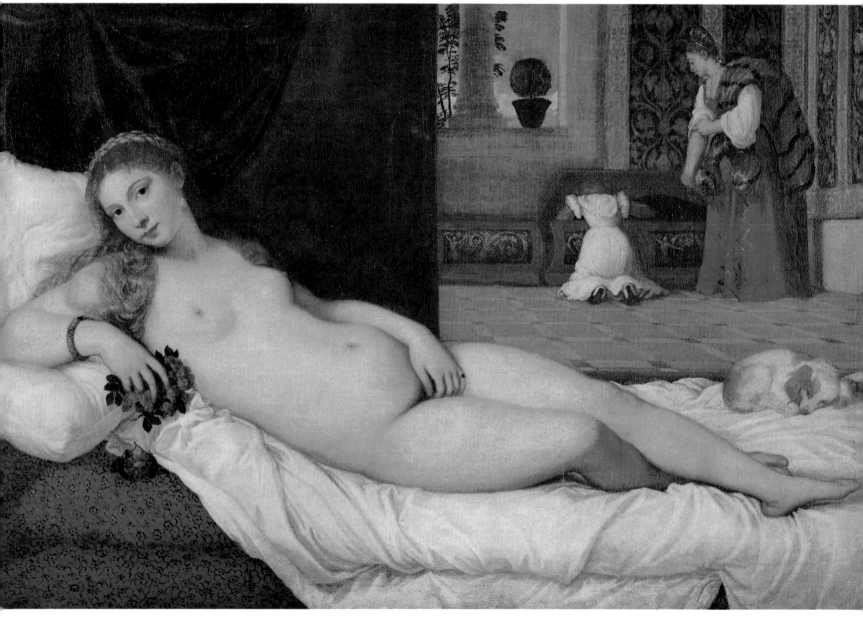

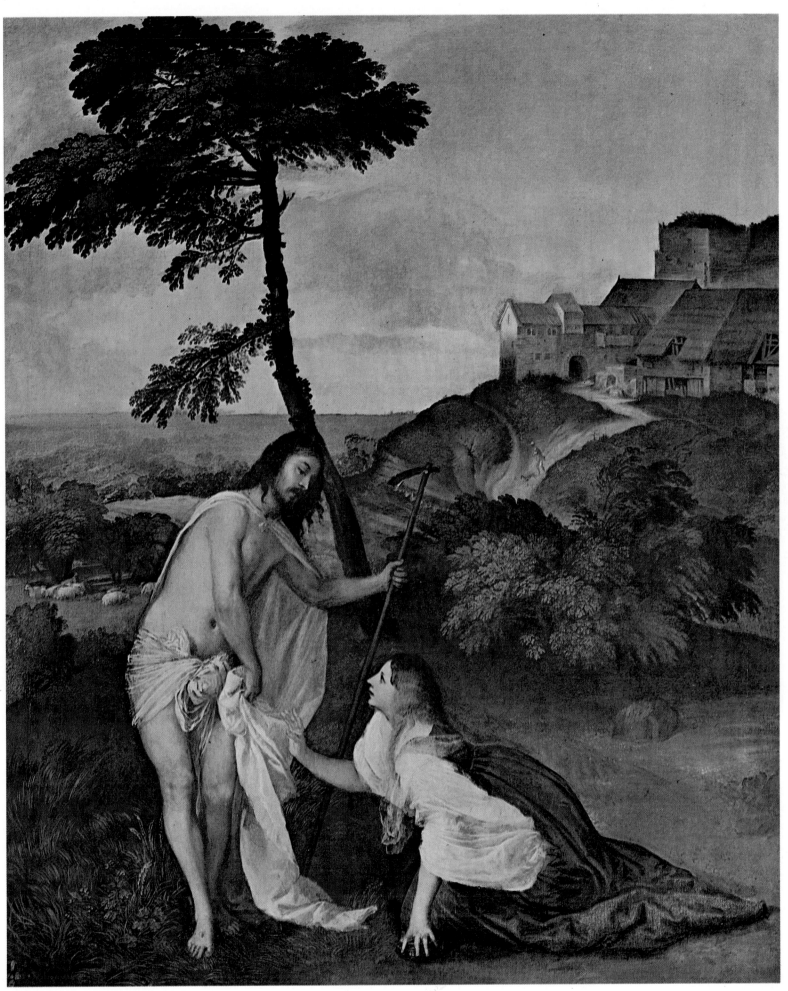

Titian: *Noli Me Tangere*, 109 × 91cm. c.1512

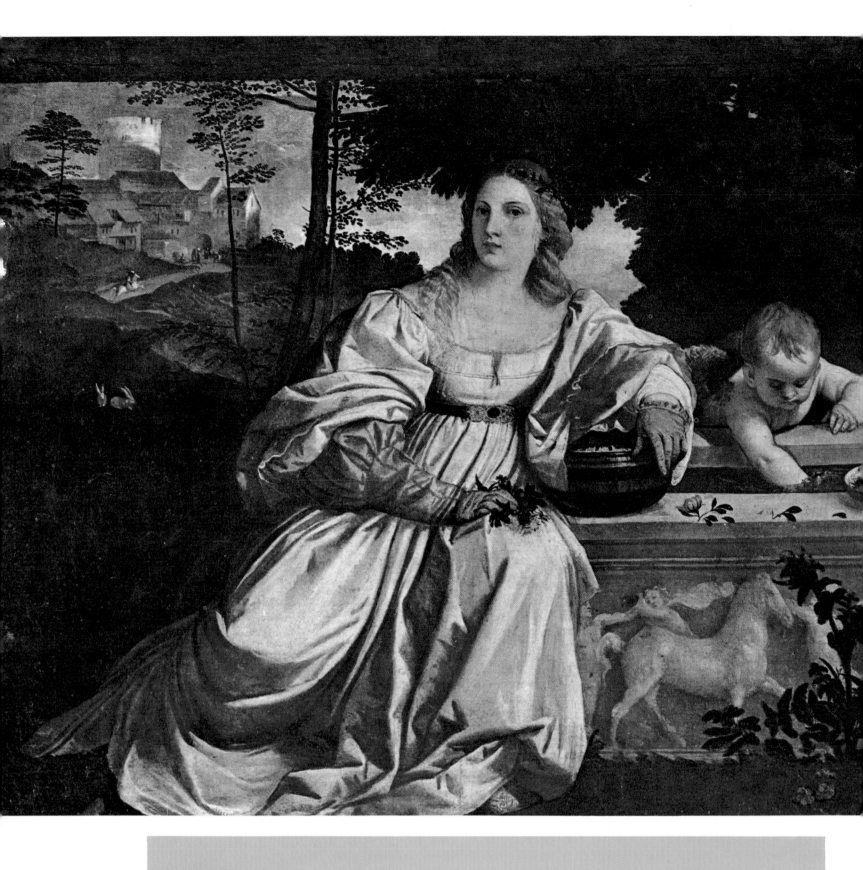

Titian: *Sacred and Profane Love*, 118 × 279cm, 1516

The present title was first suggested in the late seventeenth century. The cupid stirring up the water in the sarcophagus between the two women suggests that the theme of this picture is the contrast between two forms of Love. The richly dressed figure on the left represents the terrestrial love of mankind; opposite her, holding the burning lamp of divine love, is the 'Celestial Venus' that Marsilio Ficino had discussed as the perfect symbol of a superior realm beyond the material world. To the humanists both were virtuous, one being a stage in the ascent towards the other, from the experience of the senses to the idealized life of the mind. Beyond this, the interpretation of the other elements in the picture, notably the classical relief, remains inconclusive.

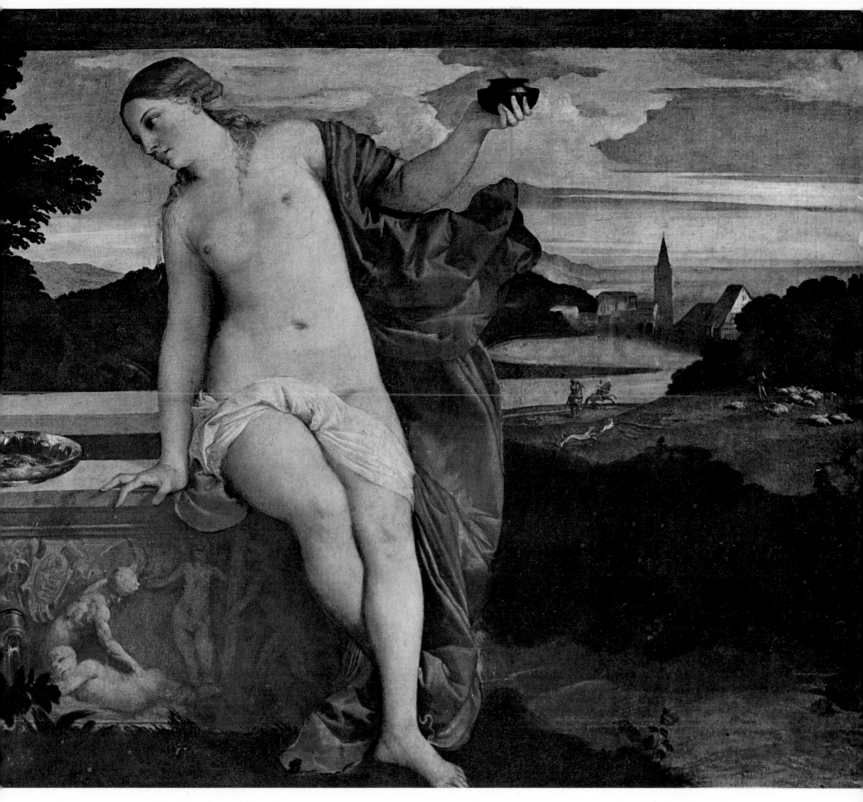

as seen in the work of the leading painters in Rome, and he seems to have participated in the free community of ideas in which famous figures and designs were adapted from one painting to another, giving to the period a certain consistency of style. Many artists suffered from this, and their work was reduced to an agglomeration of parts. But Titian was never slavish in his imitation. The motifs which he utilized were the quarry for a fertile imagination and an unparalleled facility in the handling of colour.

After the death of Giorgione in 1510 and of Giovanni Bellini in 1516, the field was open for Titian to dominate Venetian painting and he did so for the next sixty years. The sheer length of his career and the fact that he achieved a position of authority at an early stage were no doubt important factors in determining his development, but there are few artists who have been so consistently innovative

over such an extended period of time. One can only turn to painters like Delacroix or Picasso for a comparable achievement. In the sixteenth century Titian's work covers a greater range than that of any other painter, and in all types of pictures he broke new ground in matters of style, technique, and iconography. By the 1540s he had become the leading painter in Europe, invited to Rome and the North, and celebrated by popes and emperors alike. However, despite his international position, he remained essentially a Venetian artist, and he brought to his native city a reputation as an art centre which was second to none.

The irony of this in the context of the Renaissance as a whole lies in Vasari's definition of the period and his prejudice. The two cities that he considered to form the axis of the High Renaissance had both begun to decline by the end of the sixteenth century. Florence became a pro-

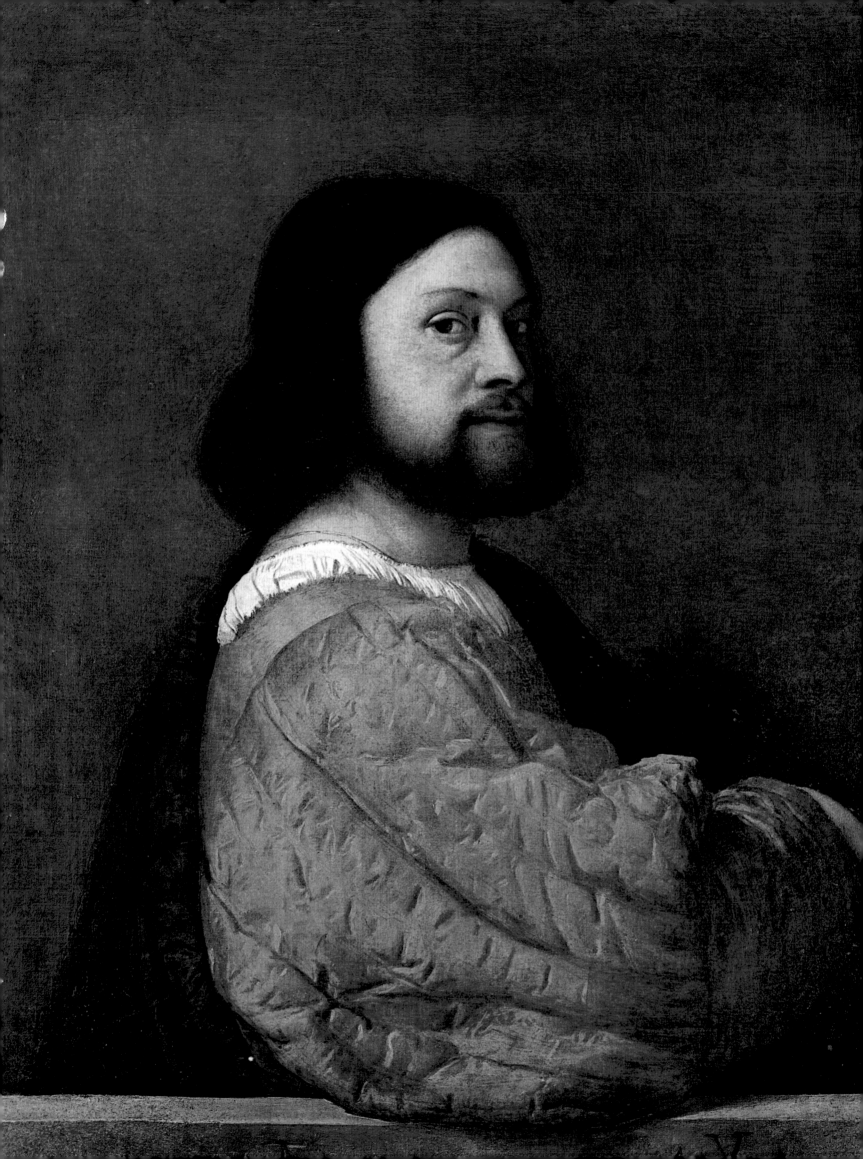

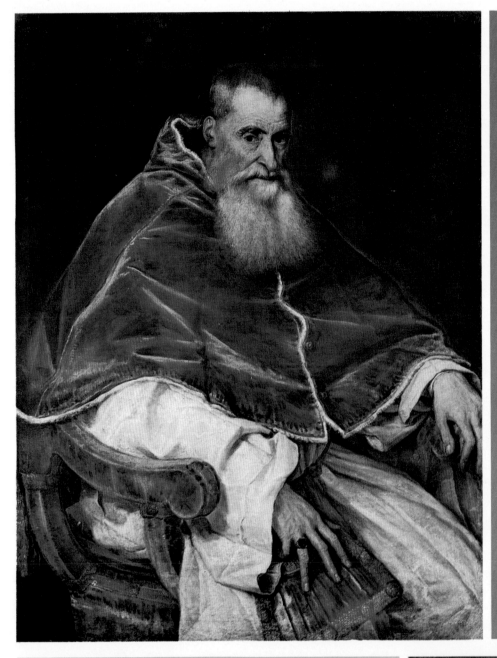

Titian: *Portrait of Man with a Blue Sleeve*
Titian: *Portrait of Pope Paul III*
Titian: *Charles V at Mühlberg*
(page 78)

As in all other branches of art, Titian was the complete master of portraiture. From the early works in the style of Giorgione like the *Man with a Blue Sleeve*, where the arm resting on the traditional parapet has become the excuse for a dazzling tour de force in the depiction of luxurious material, to the portraits of his middle years when the artist's services were demanded by popes and emperors, Titian maintained an unparalleled range and depth of characterization. The portrait of Charles V is particularly interesting since it recalls the famous antique statue of the Roman Emperor Marcus Aureiius. This traditional symbol of strength and authority has been adapted to celebrate the victory of the modern emperor in a battle against the Protestant forces.

LEFT **Titian:** *Portrait of Pope III*, 106 × 85cm, 1543

Right **Titian:** *Nymph and Shepherd*, 149·6 × 187cm, c.1570

Although the term 'Impressionistic' can be misleading, in this context it does suggest how the range of effects that Titian had mastered in the technique of oil painting was hardly equalled until the nineteenth century. The painter Palma Giovane, who assisted him in his late works, described Titian's working methods:
'He laid in his pictures with a mass of colour which served as a groundwork for what he wanted to express . . . With the same brush dipped in red, black or yellow he worked up the light parts and in four strokes he could create a remarkably fine figure . . . Then he turned the picture to the wall without looking at it, until he returned to it and looked at it critically, as if it were a mortal enemy. Thus by repeated revision he brought his pictures to a high state of perfection, and while one was drying he worked on another . . . Sometimes he used his finger to dab a dark patch in a corner as an accent or to heighten the surface with a bit of red like a drop of blood. He finished his figures like this and in the last stages he used his fingers more than his brush.'

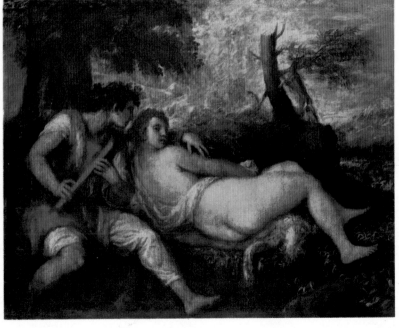

OPPOSITE **Titian:** *Portrait of a Man with a Blue Sleeve*, 81 × 66cm, c.1512

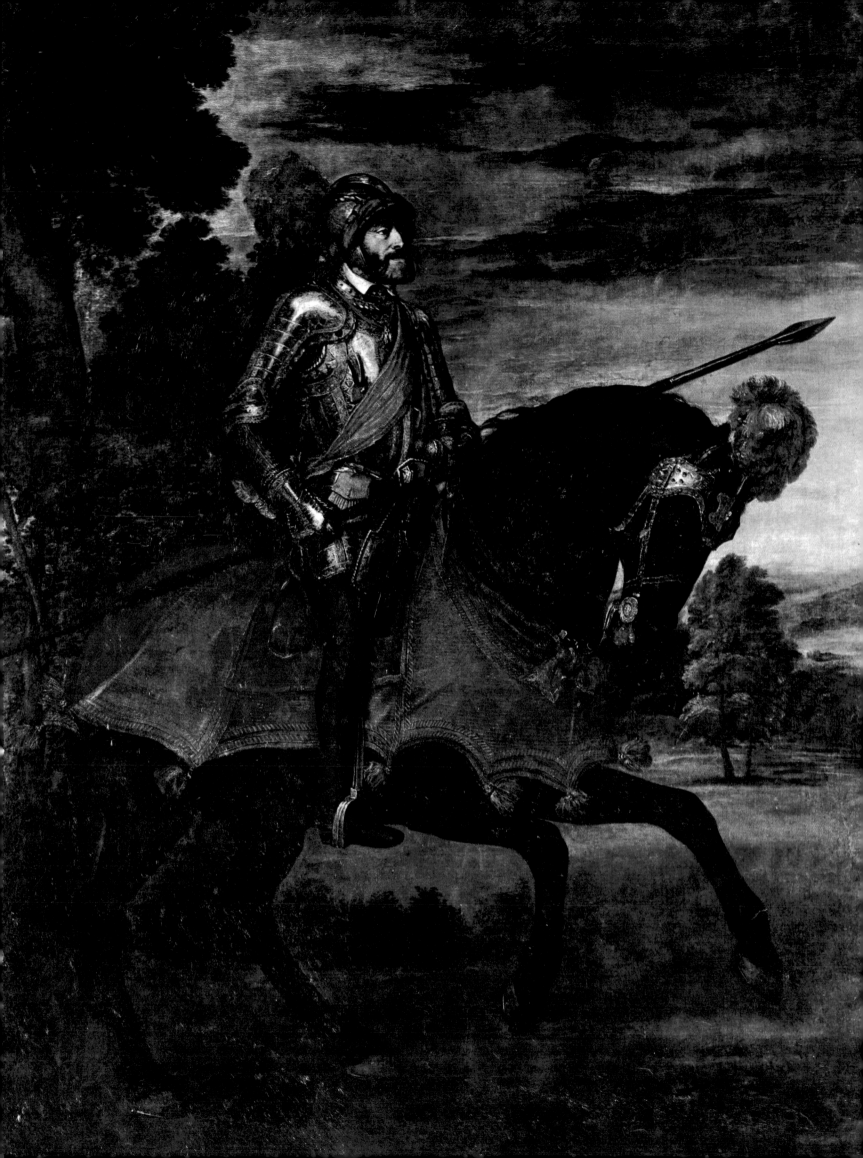

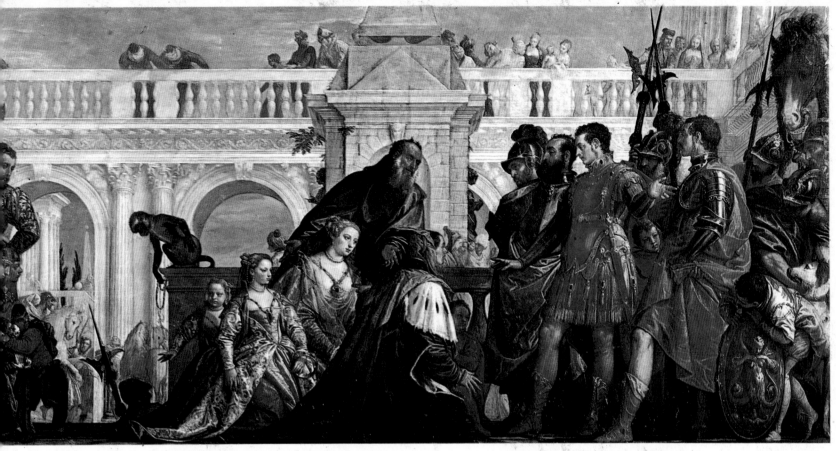

Veronese: *The Family of Darius before Alexander*, 234 × 437cm, c.1565

Veronese: *Moses
Saved from
the Waters*,
50 × 43cm

vincial centre ruled by the Medici and outside the main-
stream of European art. And although the grand schemes
continued into the age of the Baroque Rome was already
assuming its role as the 'Museum of Europe' for foreign
artists to interpret the faded remnants of a bygone golden
age. Vasari was aware of this and he acknowledged that,
after the perfection of Michelangelo, a decline was inevit-
able. He had hoped, however, that his own writings would
help to avert it by making artists aware of their heritage. The
Venetians on the other hand, through Bellini and Titian,
had founded a glorious tradition, enshrining the humanistic
principles of the Renaissance, which could still be seen in the
work of Tiepolo in the second half of the eighteenth century.

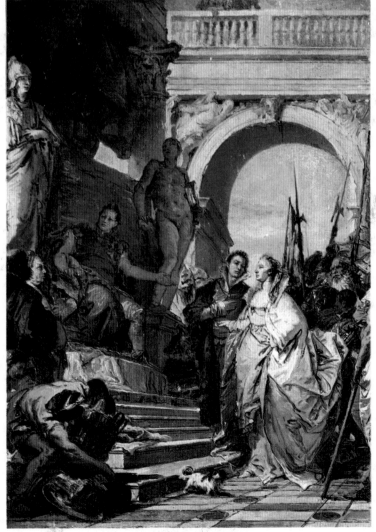

Tiepolo: *The Continence of Scipio*, 61 × 44cm, 1743

OPPOSITE **Titian**: *Charles V at Mühlberg*, 332 × 279cm, 1548

List of Illustrations

Bibliography

BAXENDALL, MICHAEL: *Painting and Experience in Fifteenth-Century Italy*, 1972.
BLUNT, ANTHONY: *Artistic Theory in Italy, 1450-1600*, 1962.
BURCKHARDT, JAKOB: *The Civilization of the Renaissance in Italy*, 1945.
LEVEY, MICHAEL: *Early Renaissance*, 1967.
PANOFSKY, ERWIN: *Renaissance and Renascences in Western Art*, 1965.
VASARI, GIORGIO: *Lives of the Artists*, translated by George Bull, 1965.
WILDE, JOHANNES: *Venetian Art from Bellini to Titian*, 1974.
WÖLFFLIN, HEINRICH: *Classic Art*, 1952.